# Drone Art: Baltimore

## Created by Terry & Belinda Kilby

Enjoy Baltimore
from our point of view!
Terry & Belinda

The art challenges the technology, and the technology inspires the art.

-John Lasseter

# Dedication

This book and the collection of aerial photographs contained within it is dedicated to our family members who are our biggest inspirations.

Ted Kilby, Terry's father who passed in 1984 when Terry was eleven years old. Ted's vast array of skills, craftsmanship and his drive to succeed are qualities that have lived on and endured through Terry. Ted took the time to instill the DIY mentality of his generation into his son.

Sue Kilby, Terry's mother, whose warmth and love encourages us to make the most of ourselves in all of our endeavors. Taking over the family restaurant while fulfilling the involved roles of both mother and father is a testament to her strength and will to persevere.

Athena Petry, Belinda's single mother who passed away in 1994 when Belinda was nineteen years old. Athena, a photojournalist and speechwriter for the Army, took tremendous pride in striving for excellence in her work. She traveled abroad with Belinda, exposed her to a great deal of art, and always made sure Belinda had art supplies. She also reminded her often that "the world doesn't owe you a thing." Pride in producing quality, first-rate work is her legacy.

Bradleigh Chance, Belinda's daughter, who is currently a broadcast journalism and philosophy major at University of Maryland. Wise beyond her years, Bradleigh sets the highest example of a an unrelenting work ethic while displaying grace and style.

Thank you all so much for modeling these characteristics, for they have made us who we are.

To confine our attention to terrestrial matters would be to limit the human spirit.

-Stephen Hawking

# Contents

Technology, like art, is a soaring exercise of the human imagination.

-Daniel Bell

# Introduction

This is a story about a marriage. Beyond the marriage of two people is the marriage of two ideas that became an obsession: the quest to attain heights in a new way and to document those heights beautifully. It all began about three years ago. Terry, a mobile software engineer and all around techy type of guy, enjoyed tinkering with remote control cars and helicopters in his spare time. This is an activity that went back to his childhood, working alongside his father in the garage. He and a longtime friend also shared a competitive nature in seeing who could one-up each other in their scaled down driving and flying pursuits.

During one of the many routine trips to the hobby shop, Terry purchased what is known as a gum-stick camera, a small digital camera that weighs just a few grams. He quickly brought it home, and attached it to his small store bought remote control helicopter. The idea was to capture footage of- and somewhat torment- their feisty cat, BooBoo. The fourteen foot ceilings of the victorian Bolton Hill dwelling allowed Terry to get a slightly elevated perspective. At the time, the *Wild Kingdom* style video clip was an amusing precursor of what was to come.

Meanwhile, Belinda was devoting the vast majority of her time to teaching visual art for Baltimore City Public Schools. She had once aspired to be a fine art painter, but long struggled to strike a balance between her professional workload and being a serious painter. Only those artists who go to day jobs while yearning for the time and space to express themselves uninterruptedly in their chosen form understand this kind of inner ongoing conflict. The artist's

statement or vision is carried along with them in their mind, waiting for the opportunity that will enable them to get it out for the world to see.

Belinda's artistic statement had been formed way back in her college years at Salisbury University. The concept is nothing new- the idea of a journey. A journey can begin at a small scale through moving particles, a thought process, or the act of creating art. Of course, physically moving or travelling to any given destination is a journey, and on a bit larger scale a lifetime is a journey. The artwork created during a lifetime may also move from place to place often outliving it's creator. On a grander scale, we may consider plate-tectonics or galactic orbits of the universe as a journey. Everything is in constant motion. Therefore, everything is interrelated, which ultimately conveys a common sense of spirituality.

What better way to express a spiritual concept of the journey than with a creation that moves by flight? That dormant artistic vision and the initial spark of the gum-stick imagery flipped a switch. The light bulb was fully illuminated when Terry captured the next bits of RC helicopter footage. This time he ventured outdoors to fly a little higher and explore the street they lived on. Eutaw Place in the neighborhood of Bolten Hill was designed in the 1800's to compete with other premier boulevards of major cities during the victorian era. It features picturesque subjects such as Queen Anne architecture, gilded fountains, mature trees, flowering urns and patterned sidewalks that criss-cross through the landscaped median. Although poor quality, those initial outdoor images immediately brought to Belinda's mind the birds eye perspective of important historic art. Most notably, the scenes were very reminiscent of Japanese prints and Impressionism. They also bring to mind works from the Renaissance, classic Greek, ancient Aboriginal and modern eras. Two familiar artists, M.C.

Esher and Georgia O'Keefe, have featured forced aerial perspectives in their work.

The early photographer and balloonist, Gaspard-Felix Tournachon, known as "Nadar" was the first to capture aerial images of Paris, France in 1858. In 1907 German photographer, Julius Neubronner strapped small cameras to pigeons to catch literal bird's eye views. It appears that people have always been intrigued with flight and seeing their environments from elevations high above the ground. From the spiritual standpoint, another constant in human history, one could even suggest that an aerial perspective is God's view.

From all of this, well informed, successful contemporary artists not only pay homage to important art from the past, but also strive to lead art to new horizons. With this in mind, Belinda knew immediately that Terry's humble aerial images had great potential- their artistic partnership was born, and they would call their project Elevated Element. It didn't take long to determine that a custom built flying device would be necessary to carry a camera that could capture better quality photographs. Terry and Belinda now represented the marriage of traditional art and cutting edge technology. Neither of the them were multi-copter pilots, engineers or digital photographers- this set into motion a concerted effort to research and learn whatever they could about these topics. There was nobody else that they knew at that time who was involved in such endeavors.

The online community was key in getting to know other multi-copter enthusiasts. Those individuals from all over the world were generous with sharing their ideas. At first, this concept of being so open with one's hard earned intellectual discoveries was new for Belinda, and she warned Terry not to be so giving.

However, soon it became clear that sharing ideas benefits everyone involved. It's the old saying, what goes around comes around. You give to get. Seeing so many engage in building their own tech devices from simple materials was what exposed them to the Maker Movement. They realized that they had become part of a subculture of like-minded problem solvers and builders who aim to "do it themselves." Makers apply practical skills to create new things. Terry also joined a local hackerspace, which is a kind of club where members share information, and play with cool tech tools.

Winter was settling in, and the first GoPro action sports camera model had been released, so naturally it was on the top of Terry's Christmas list for 2010. He also ordered the Phoenix RC simulator software to build his confidence in piloting a multi-copter during those cold winter months. Concurrently, Terry began his first custom built tricopter prototype for mounting the GoPro. Between research, building, flying, and trips to the hobby shop and Home Depot, it became apparent that the challenge had him completely hooked. Belinda supported his efforts, finding it remarkable to witness the ingenuity that went into his ever-evolving creations. As Belinda observed Terry build, she asked many questions. It was fun to learn about the various components and steps taken to install them. As an educator, Belinda knew that having Terry explain to her what he was doing and why, would help him better master the inner workings of their art making device.

The tricopter was essentially their first flying robot and an original work of art in itself. Seeing the photos taken with it ignited a passion for envisioning compositions, and bringing those visions to fruition. They began seeing the city with fresh artistic eyes. Compositional models of art such as the rule of thirds, the golden mean and balance of visual weight are tried and true ideals

that are certainly considered when Belinda and Terry frame and crop their shots. However, they also enjoy challenging those same compositional norms. Sometimes they may place the focal point directly in the center of the pictorial space. At other times the edges of the subject may run close and parallel to the edges of the pictorial frame. They believe breaking the rules of composition, when done carefully, can add to the visual interest, and create a subtle tension. Techniques like this also give a nod to the new school of thought in art, by doing something different and unexpected.

Early on landscapes were lovely, but more importantly they were safe; the fewer cars and people around the better. Eventually they began capturing some of the iconic Baltimore architecture. Very early mornings not only provide the ideal "golden hour" of lighting, but also safer, people-free settings. Watching Terry fly a little higher on each outing to capture the larger city structures was always a shared celebration of achievement. Traveling to new places of great visual interest is another facet of the their adventure.

The GoPro photos were pleasing, but when enlarged the slightly grainier nature became apparent. This inspired the painterly oil work by Belinda over some of the large canvas prints. The GoPro photos also required additional post production editing in Photoshop. They explored HDR filtering and attempts to minimize the fish eye lens effect. The more the duo learned about digital photography, the more they desired crisper, better quality photos. Better photos required a better camera. A better camera required a bigger, badder multicopter.

By the time this story is told, an entire fleet of Kilby flying robots have been built to accommodate two GoPros, the Canon S90 and a Sony NEX Series. Terry has built tri-copters, leading up to an octo-copter to discern which unmanned

aerial vehicle (UAV) would best accomplish their photographic goals. They have determined that so far a hexa-copter or an altered H-frame quadcopter is what has worked best for their photography. This is purely a matter of personal preference. Ultimately, Elevated Element's quest to capture their most stunning photos yet continues and evolves.

Imagination will often carry us to worlds that never were, but without it we go nowhere.

-Carl Sagan

# Safety and Responsible UAV Flight

A person interested in getting involved with unmanned aerial photography must understand that this is a very serious undertaking. The need for taking every precaution for safety can not be stressed enough. Gradually building your comfort level, by starting off with very small remote control aerial vehicles is a must. Jumping to a machine that is too large too soon is considered reckless and irresponsible in the UAV community. Although there are out of the box multi-copters that are ready to fly, and are equipped with a gps enabled autopilots, one should never rely on those systems to fly safely. Learning the basic principles of flight are critical. Even very experienced pilots should never fly above people. There is always the chance that the equipment could malfunction in some technical way. It is highly recommended that one builds their own multi-copter, so that they have a greater overall understanding of how the machine works.

In addition, working with a partner enables the non-pilot to be a second set of eyes, who can communicate with curious bystanders. People may try to approach and engage in conversation while the pilot is flying. Roping off an area for a clear takeoff and landing is another smart practice. Strategies like these best insure the ability to fly in a responsible manner.

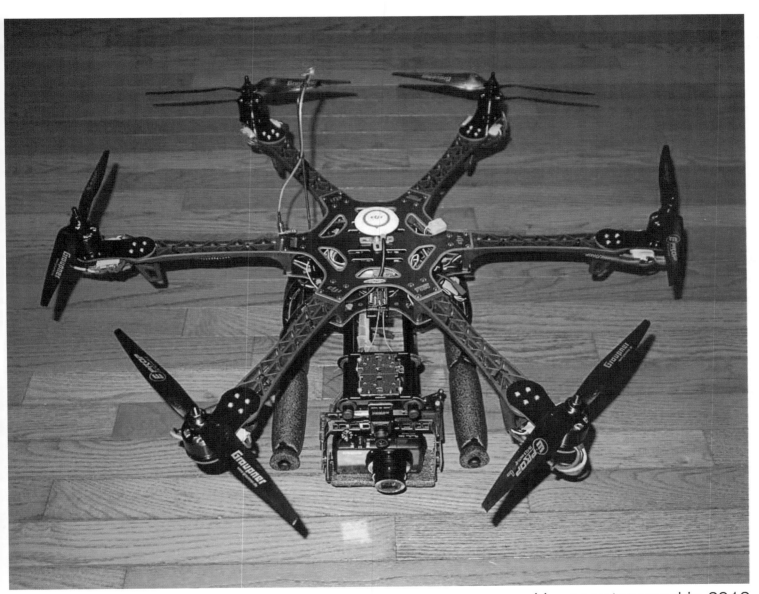

Hexacopter used in 2012

I am always doing what I cannot do yet, in order to learn how to do it.

-Vincent van Gogh

# Photo Collection

The following collection of photos were all shot using one of several different small unmanned aerial vehicles. This project started as a research effort, but eventually turned in to a passion. The collection loosely follows a chronological series of events that highlight various technological and artistic achievements. It also shows an evolution from curious tinkerer to accomplished photographers. We do not lay claim that every photograph contained in this collection was professionally shot with the highest grade equipment and expertise. Rather, this collection documents the journey taken by two individuals who joined forces not only in life, but in this quest to obtain photographs that were simply never captured before. Selection of these shots involve many factors, but one stands above all others. We always ask, is there any other way to obtain this photo? Often times, we turn down shots that may be captured from a building across the street, or a traditional helicopter with a zoom. We exist in the sweet spot above a crane and below a plane. Those are the skies we call home.

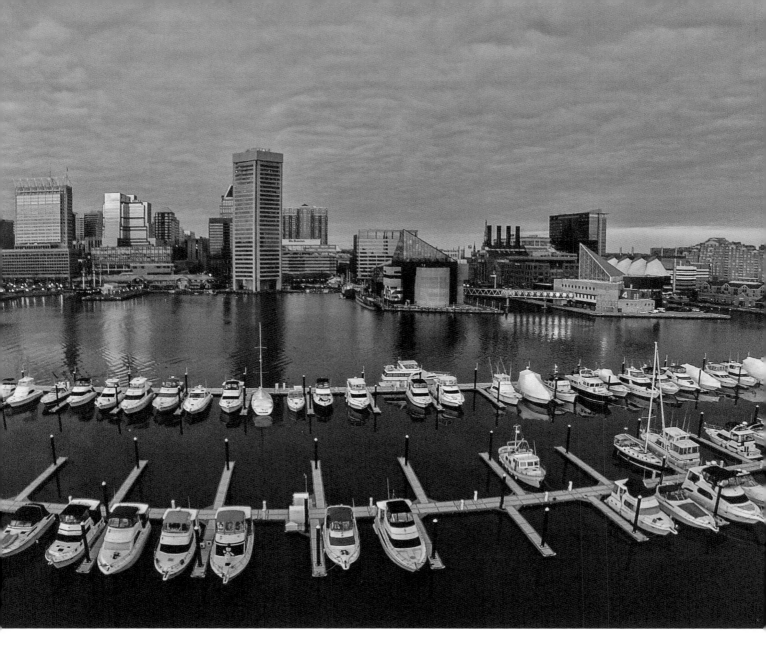

# Inner Harbor

Inner Harbor, Baltimore, MD

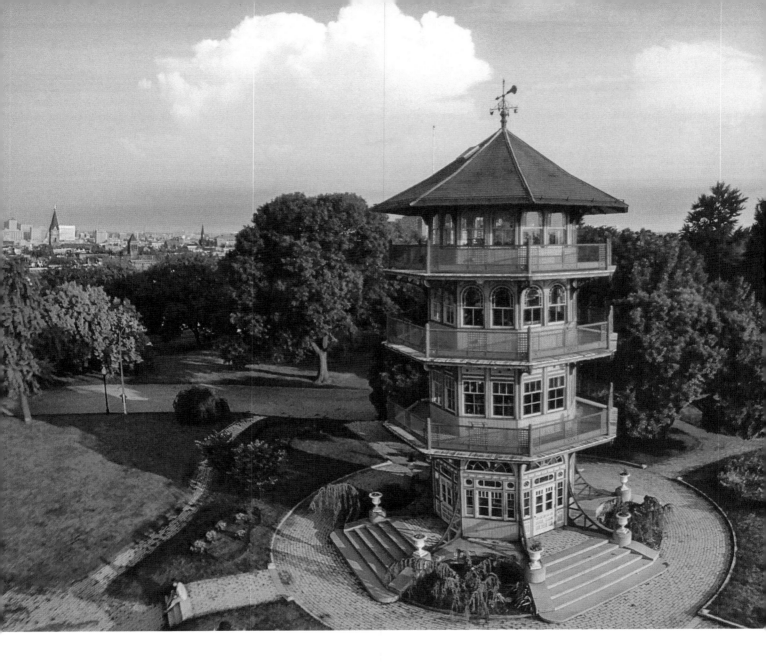

# Patterson Pagoda

Patterson Park, Baltimore, MD

13

Featured in National Geographic Traveler June/July 2013

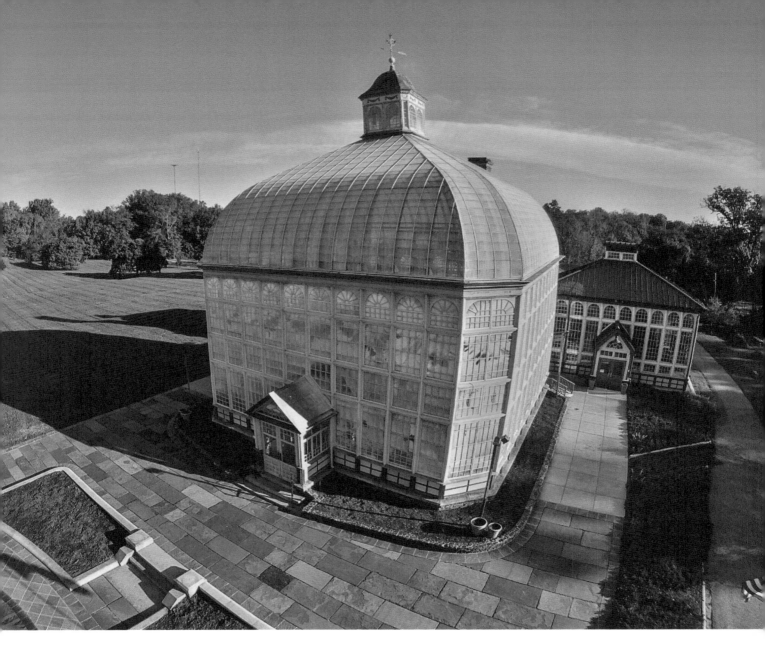

# Rawlings Conservatory

Druid Hill Park, Baltimore, MD

14

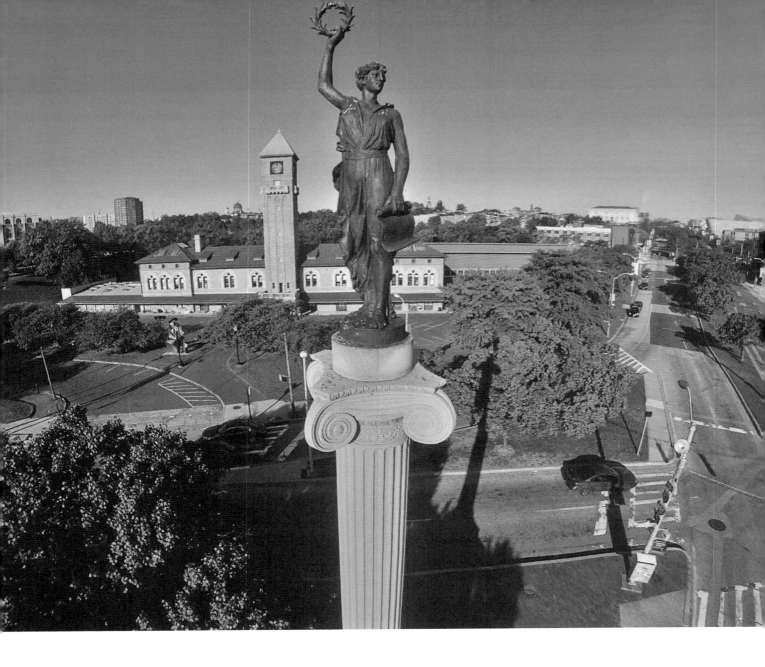

Maryland Line Monument

Mount Royal Avenue, Baltimore, MD

15

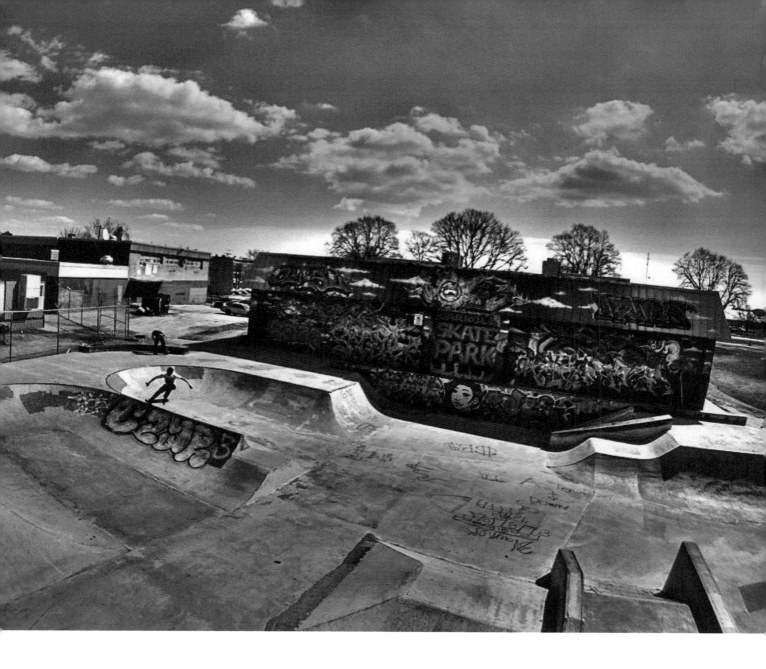

# Frontside Grind

Carroll Skate Park, Baltimore, MD

16

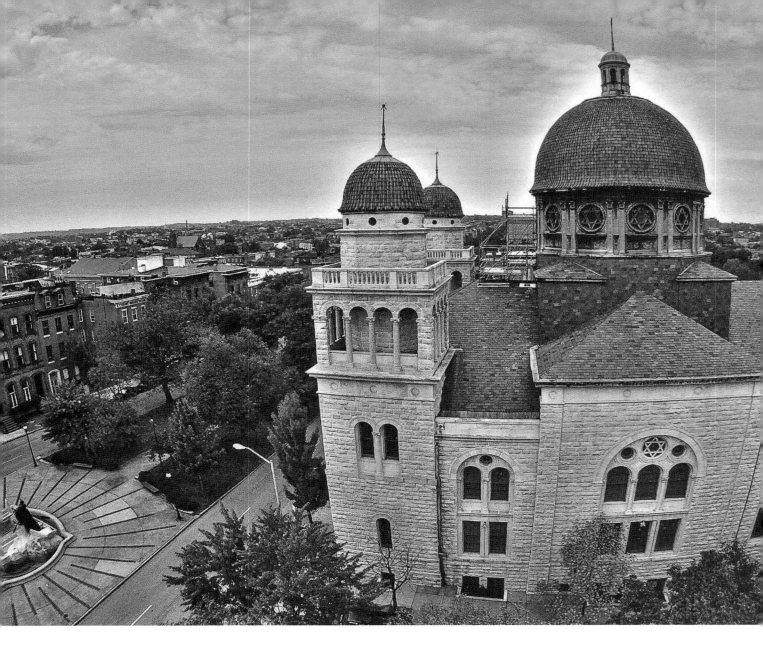

Masonic Temple

Bolton Hill, Baltimore, MD

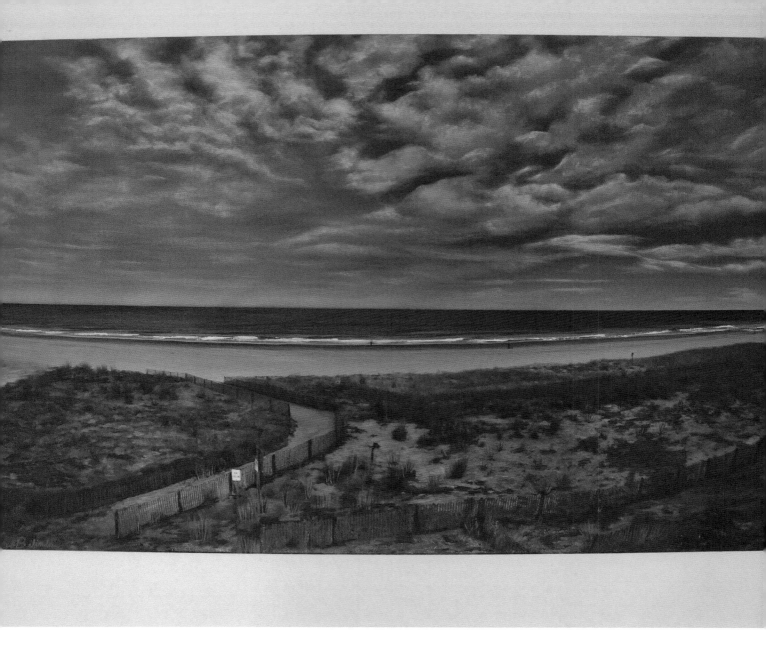

# 62nd Street Dune: Oil over canvas print

Ocean City, MD

18

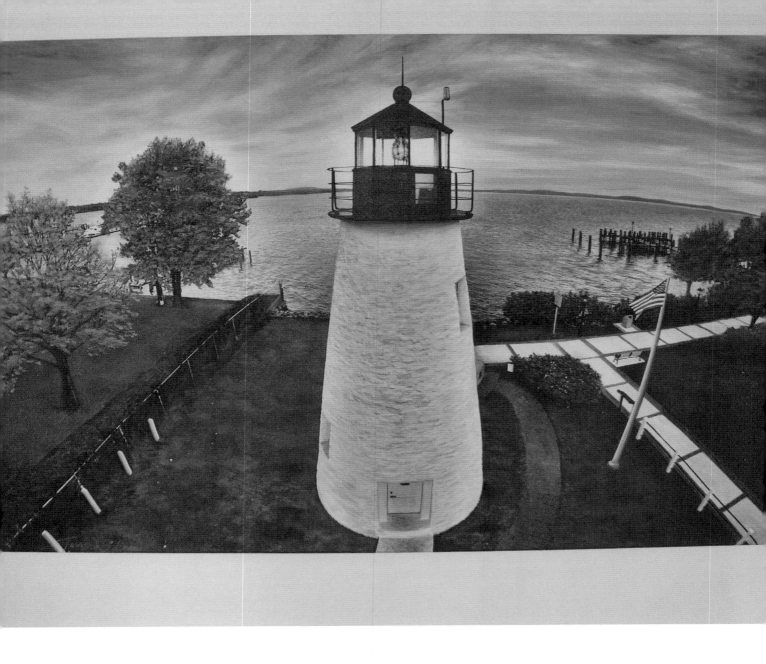

Concord Point: Oil over canvas print

Havre de Grace, MD

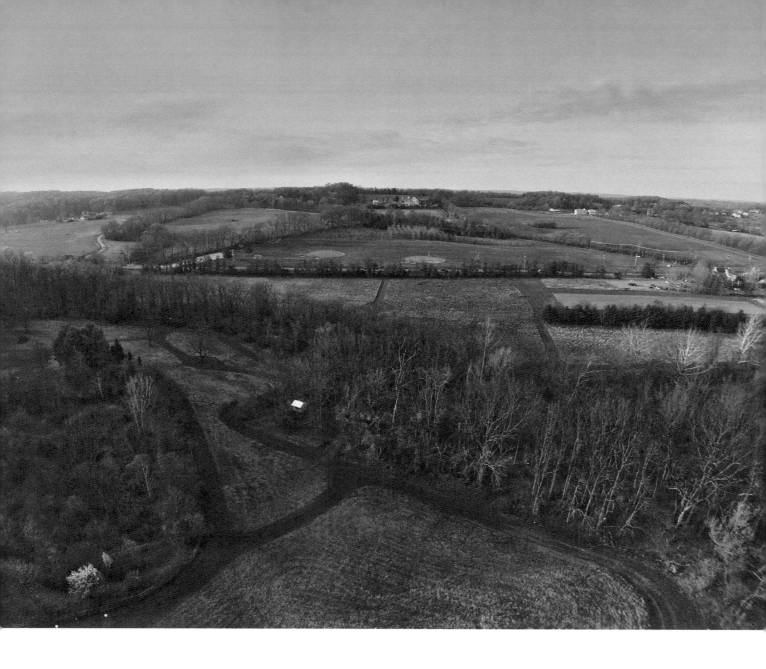

# Oregon Ridge

Cockeysville, MD

20

# Turkey Point 01
North East, MD

# Turkey Point 02
North East, MD

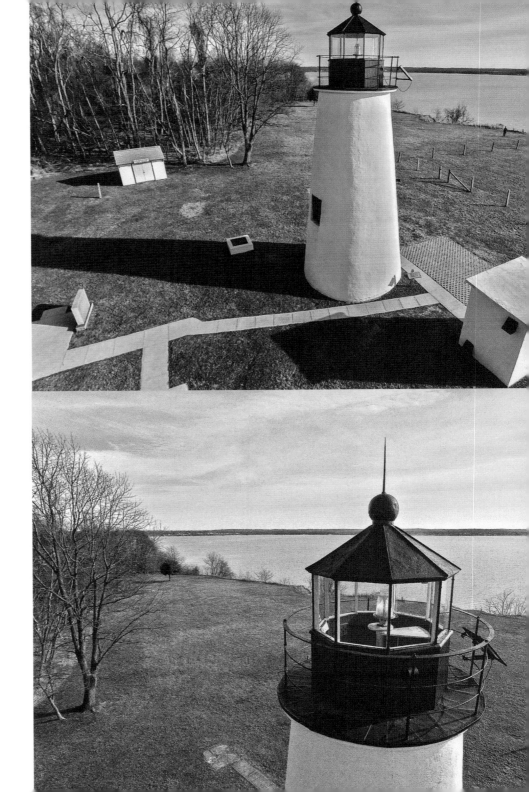

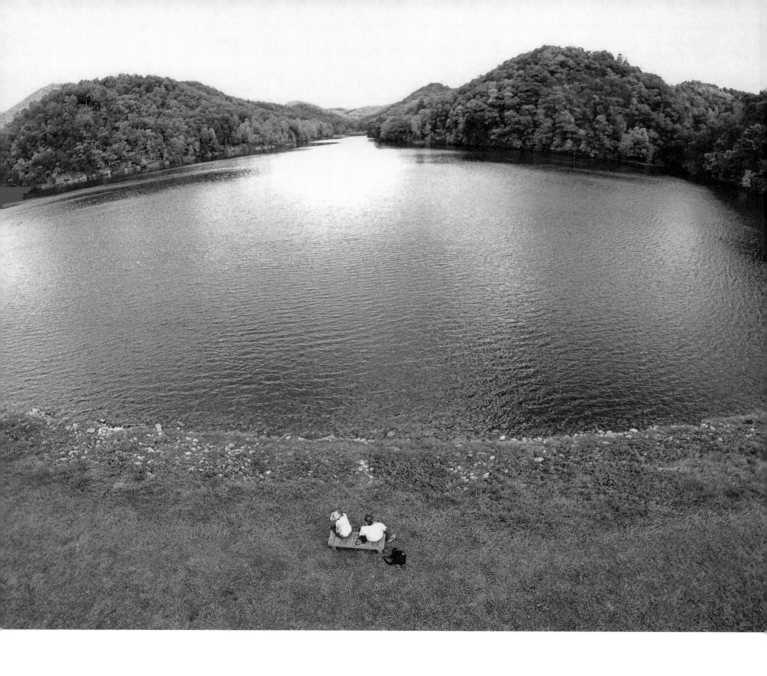

# Hungry Mother Lake 01

Marion, VA

22

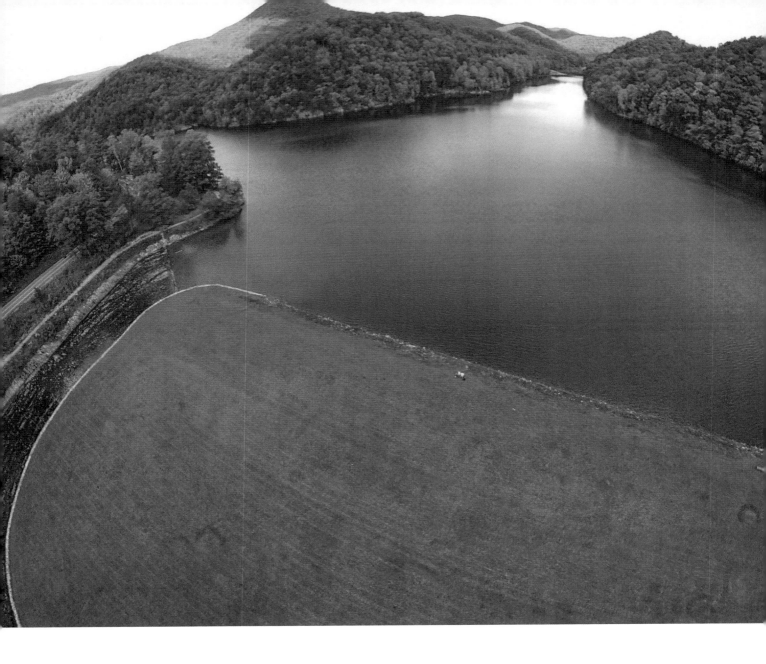

## Hungry Mother Lake 02

Marion, VA

23

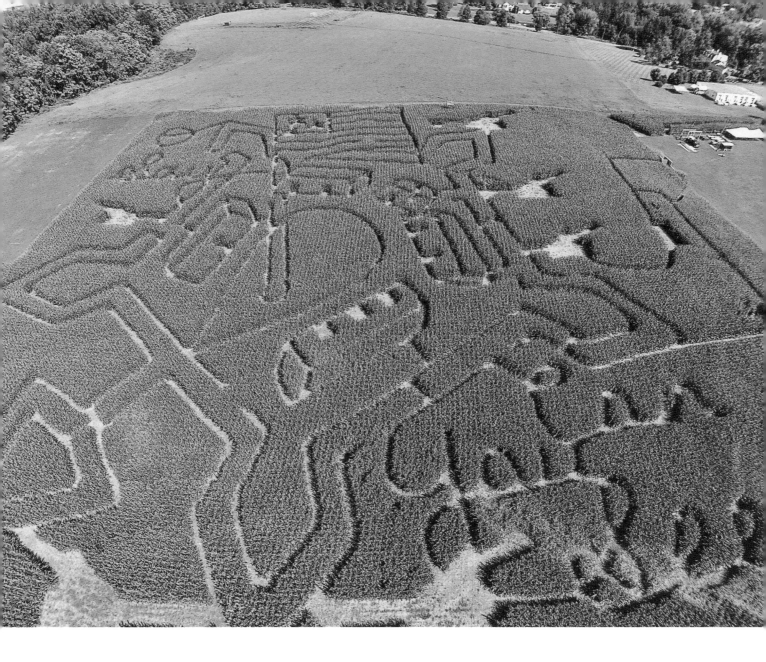

## Bicentennial Maize

Kingsville, MD

24

# The War of 1812

One of the most famous moments of Baltimore history was the Battle of Baltimore during the War of 1812. After the British took Washington, D.C., they burned and looted the White House, Capitol, Treasury, War Department and other public buildings before starting on their way towards Baltimore. It was here that they met their match and the war finally took a turn in favor of the United States. After holding off the British by land at North Point and by sea at Fort McHenry, it was just off those shores that Francis Scott Key was inspired to write the poem that would later influence the words to our national anthem, The Star-Spangled Banner. The words "Oh Say Can You See" hold a special meaning in Baltimore, and can be found injected in to all types of local culture. During 2012, Baltimore celebrated the bicentennial of the War of 1812 with several events through out the year. In the corn maze on the opposite page, you can see the star shaped outline of Fort McHenry with the famous opening line of our national anthem cut into the maze. This is just one small example of how Baltimore prides itself on it's colonial history.

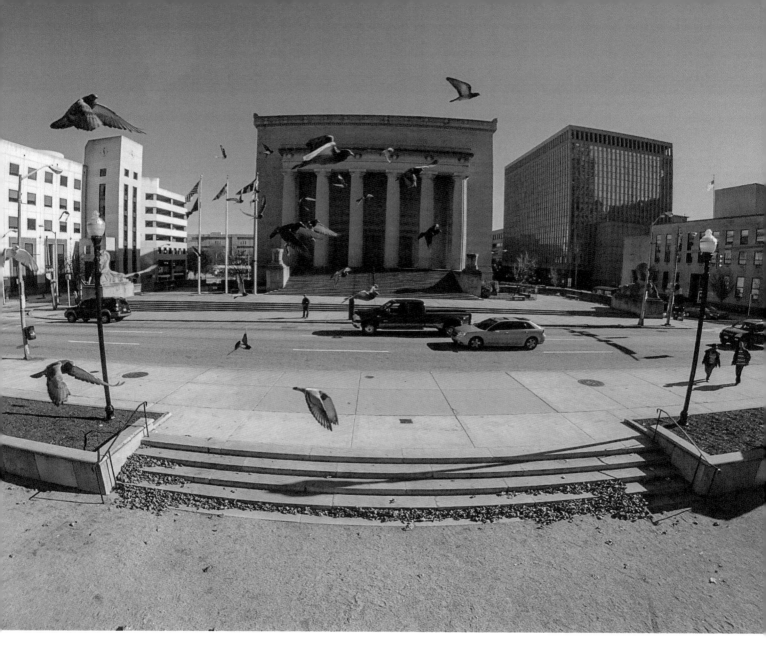

# Pigeon Flight

City Hall, Baltimore, MD

26

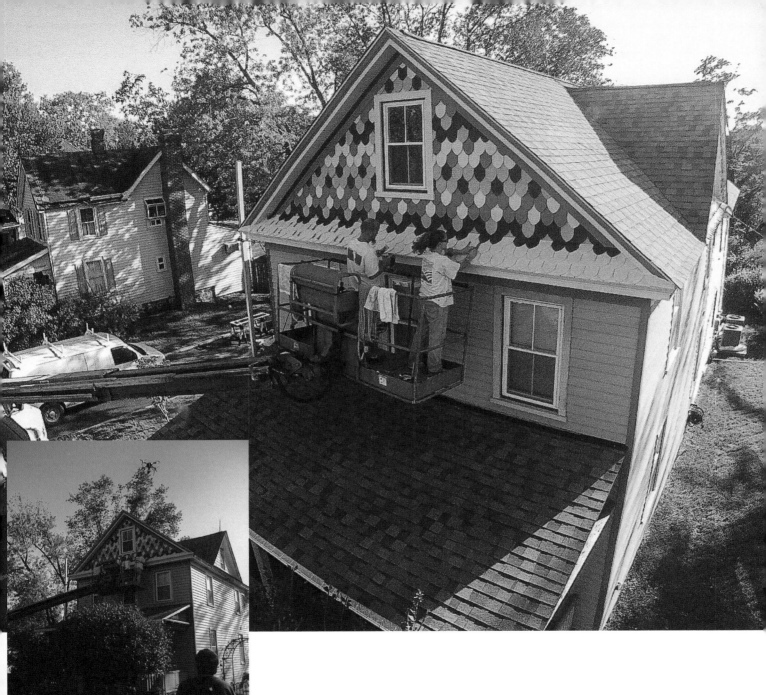

## Victorian Rehab

Aberdeen, MD

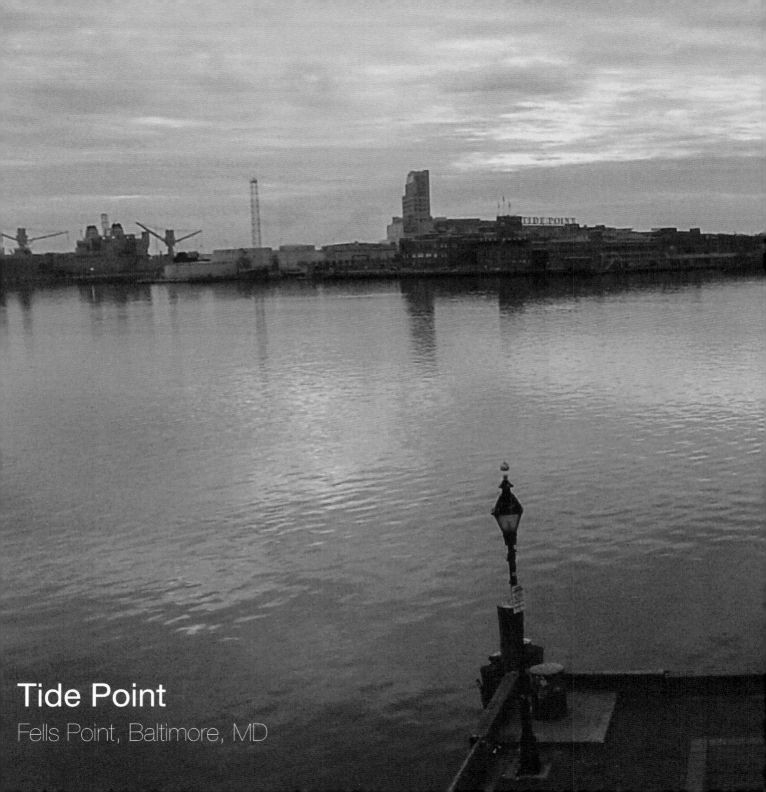

# Tide Point

Fells Point, Baltimore, MD

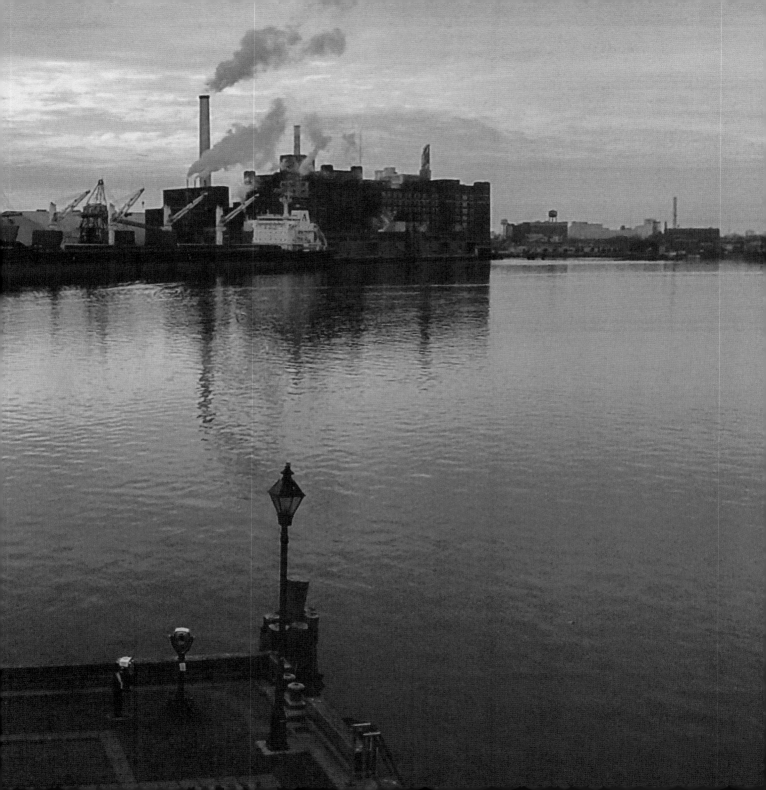

# Washington Monument

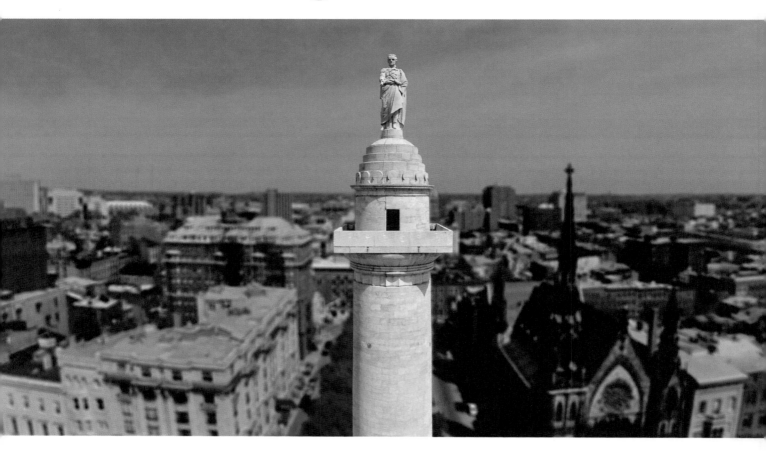

At 178 feet, the George Washington Monument was once the highest point in Baltimore. It is located in the center of the Mount Vernon Cultural District. The Walters Art Museum and The Peabody Conservatory are among many of the neighbors that contribute to the strong presence of the arts in Charm City. Reaching the top of the monument was the first major milestone set for Elevated Element, and one that took almost a year to achieve. A careful flight plan, additional training and advancements in flight controller technology all needed to be in place before the pair felt comfortable attempting this shot. Others are not encouraged to attempt this type of photography without first taking a similar path to their end goal.

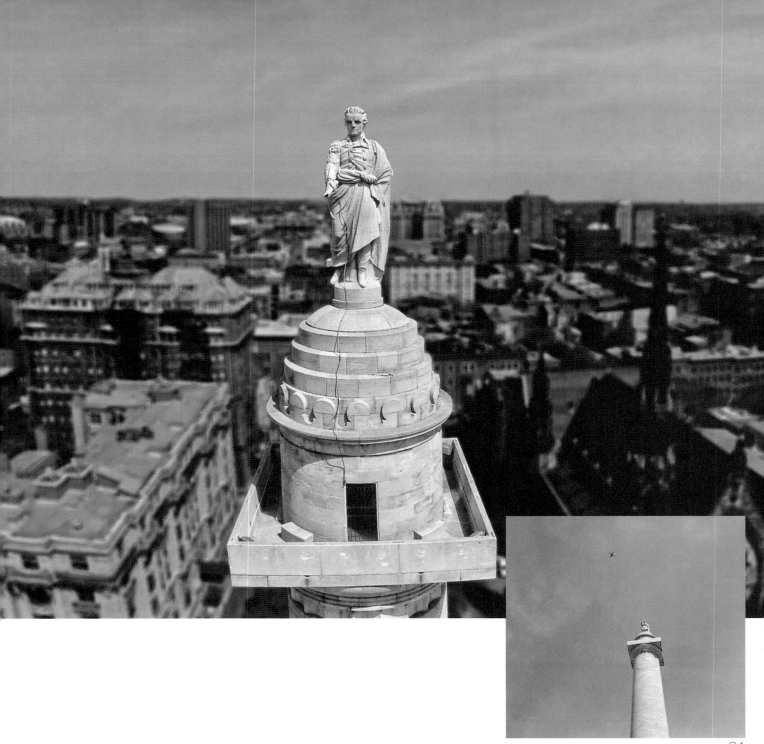

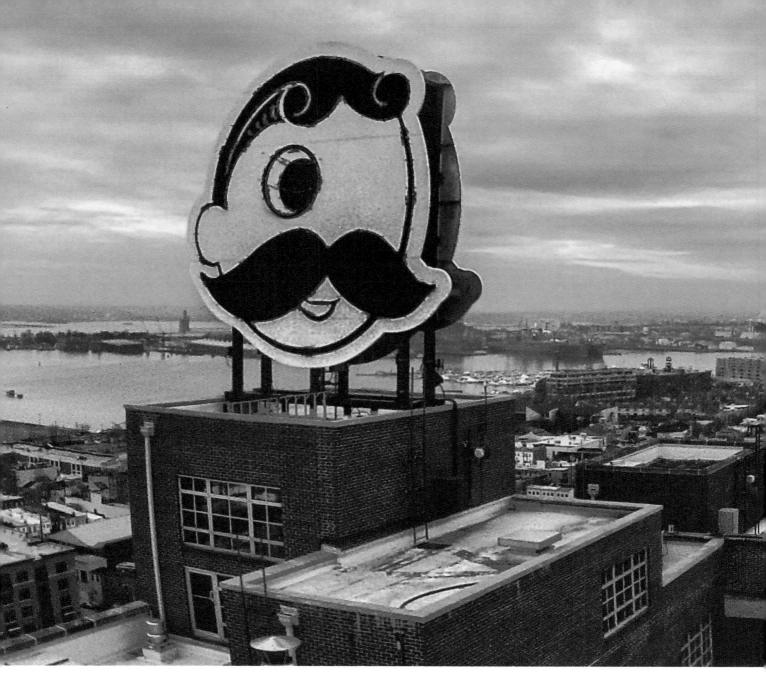

# Bohtimore

Brewers Hill, Baltimore, MD

# McHenry Row

Locust Point, Baltimore, MD

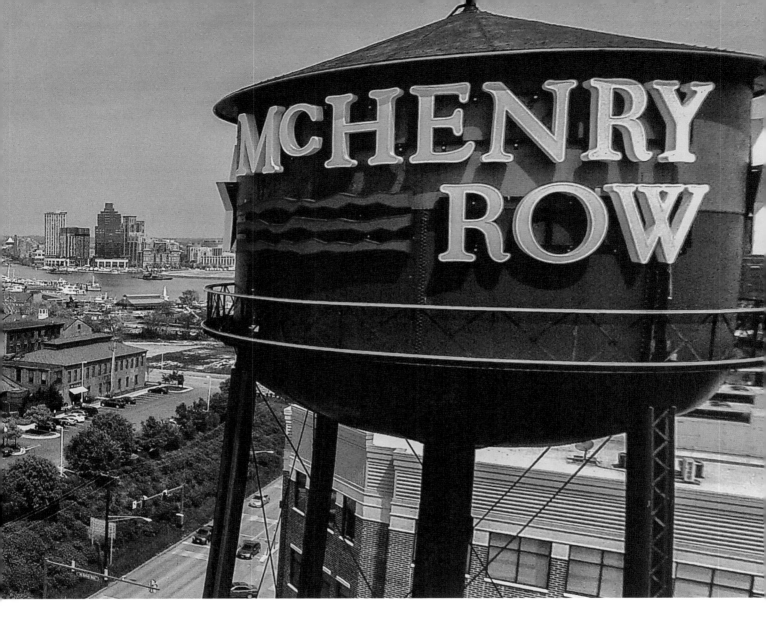

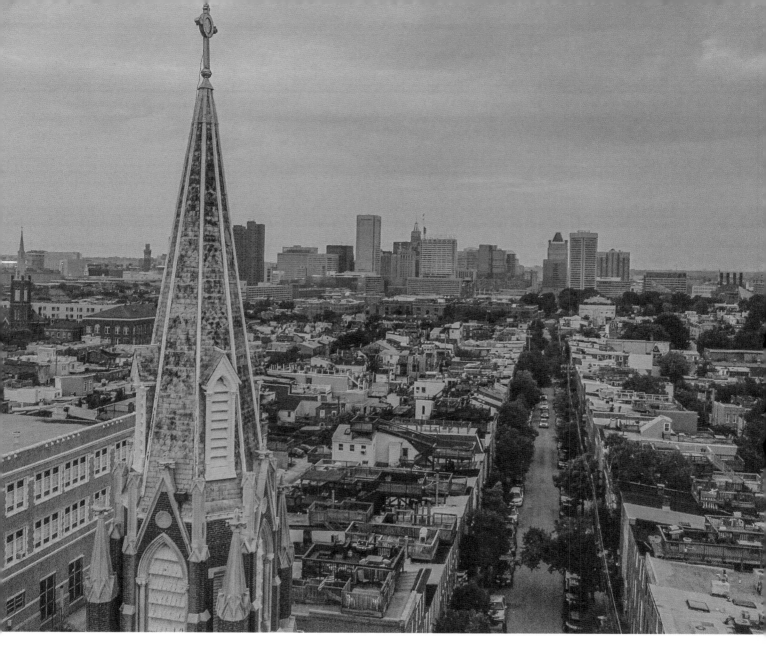

# Riverside Ave

Federal Hill, Baltimore, MD

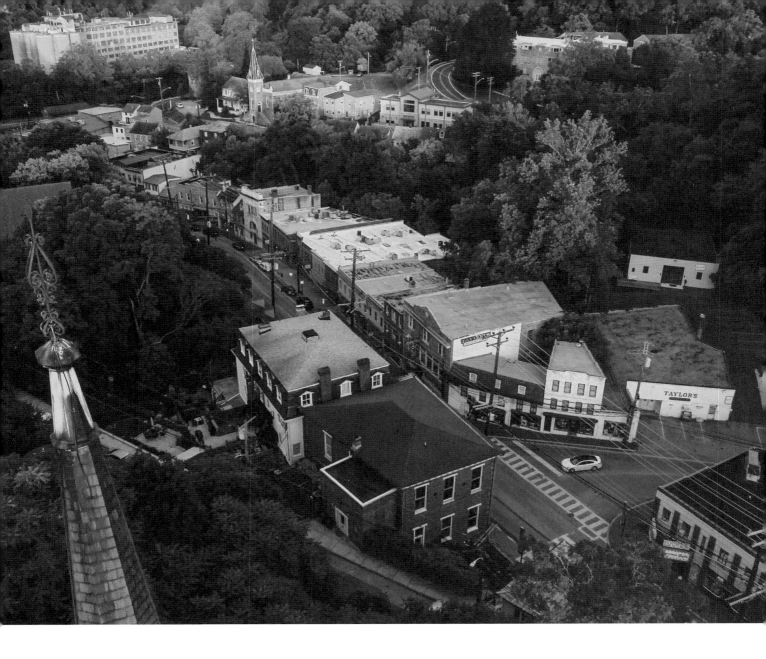

# Main Street

Ellicott City, MD

37

# Last Ride

Owings Mills, MD

38

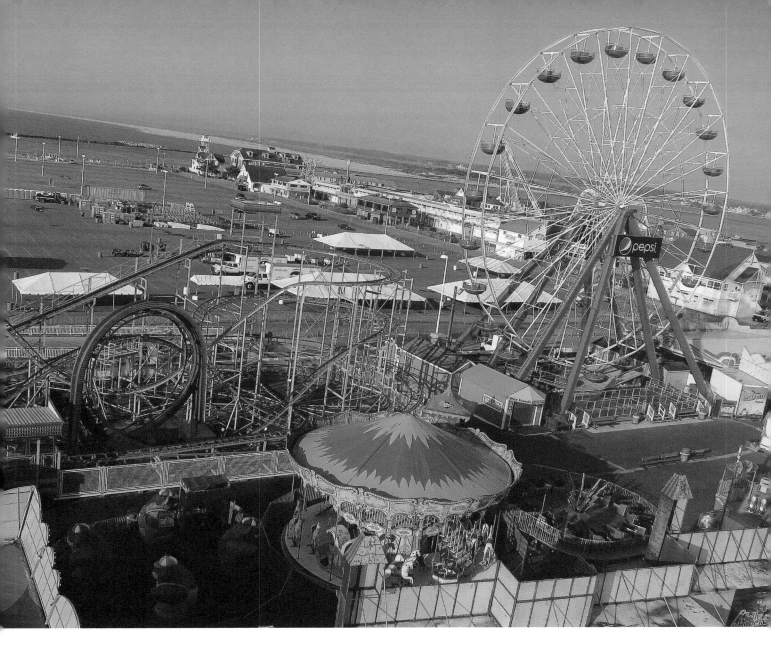

Inlet Fun

Ocean City, MD

39

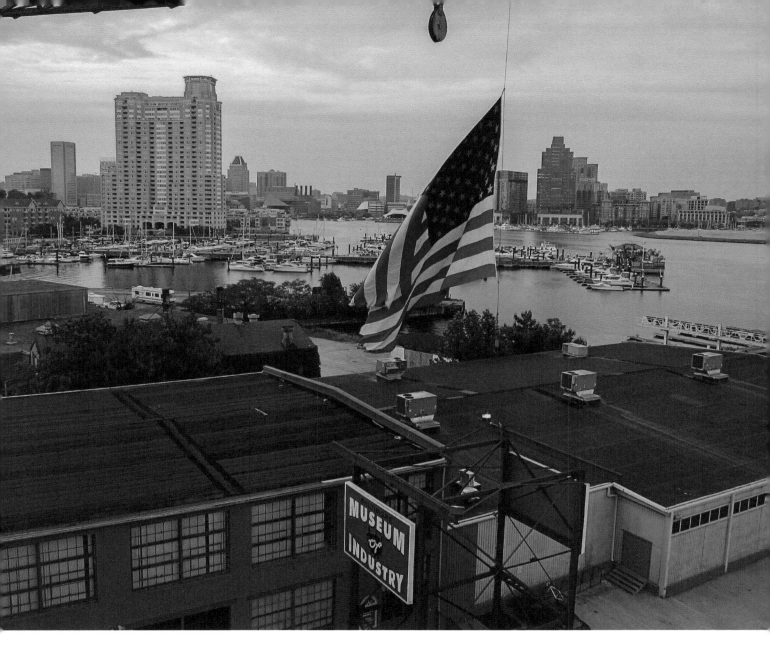

# Museum Of Industry

Inner Harbor, Baltimore, MD

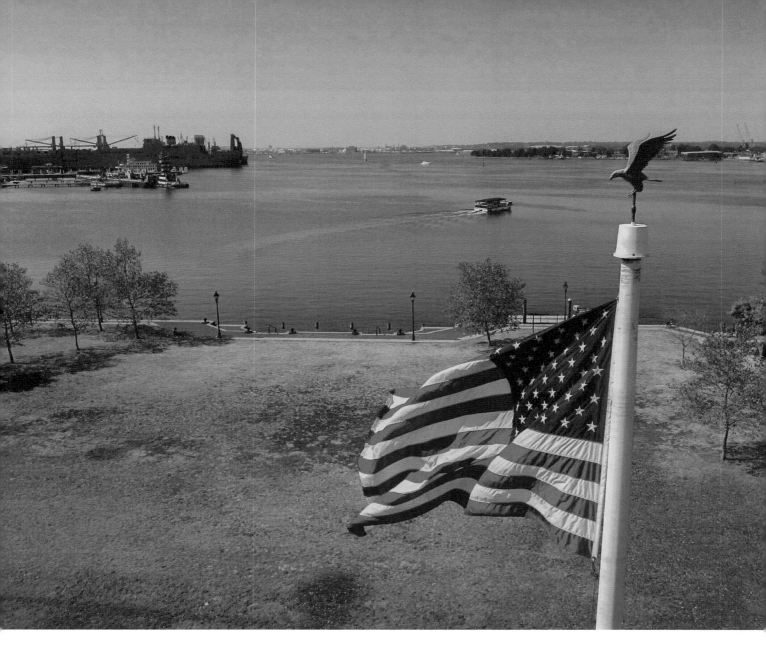

Water Taxi

Canton, Baltimore, MD

41

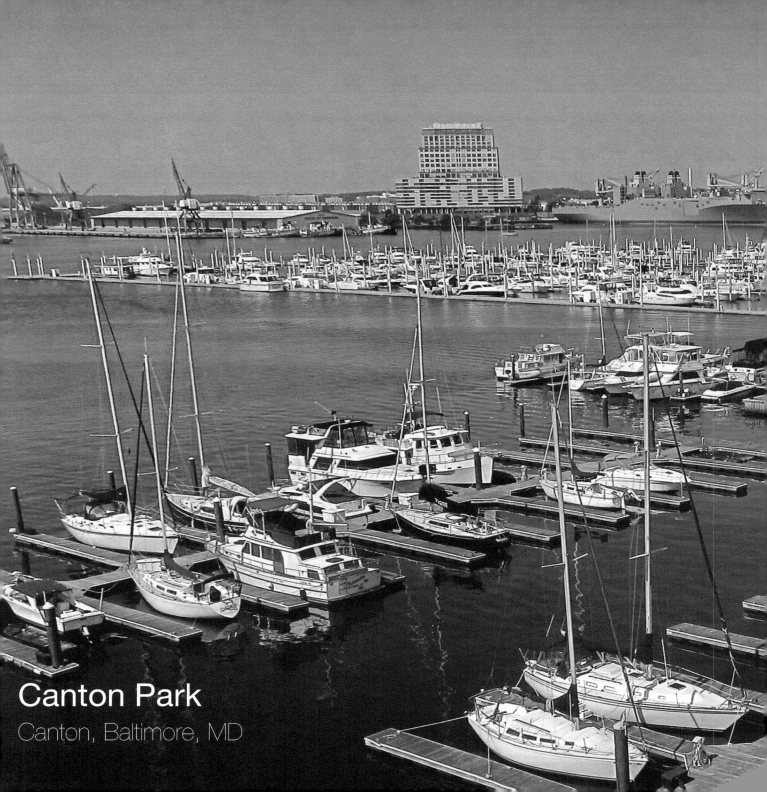

# Canton Park
Canton, Baltimore, MD

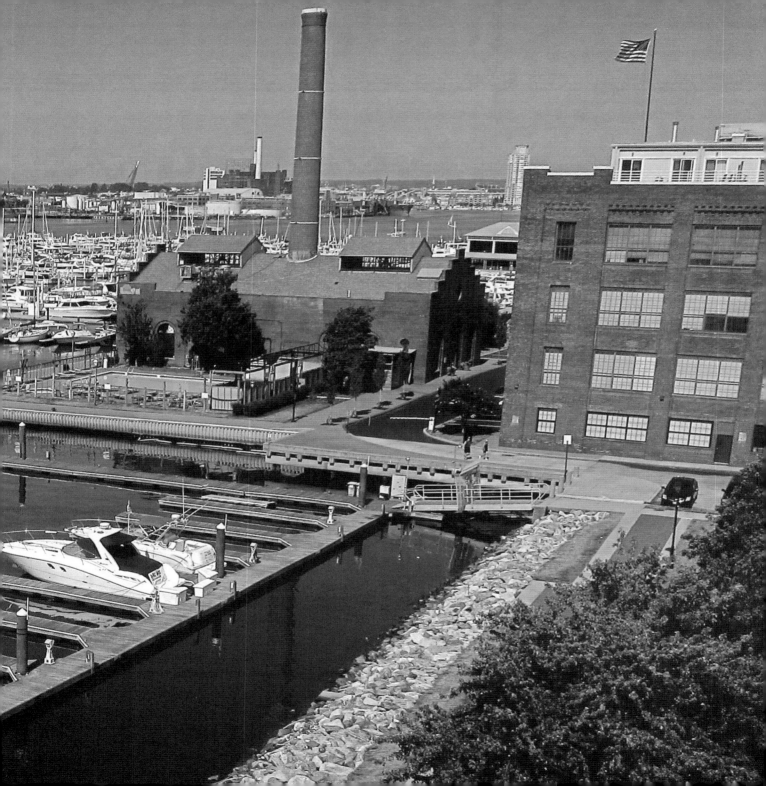

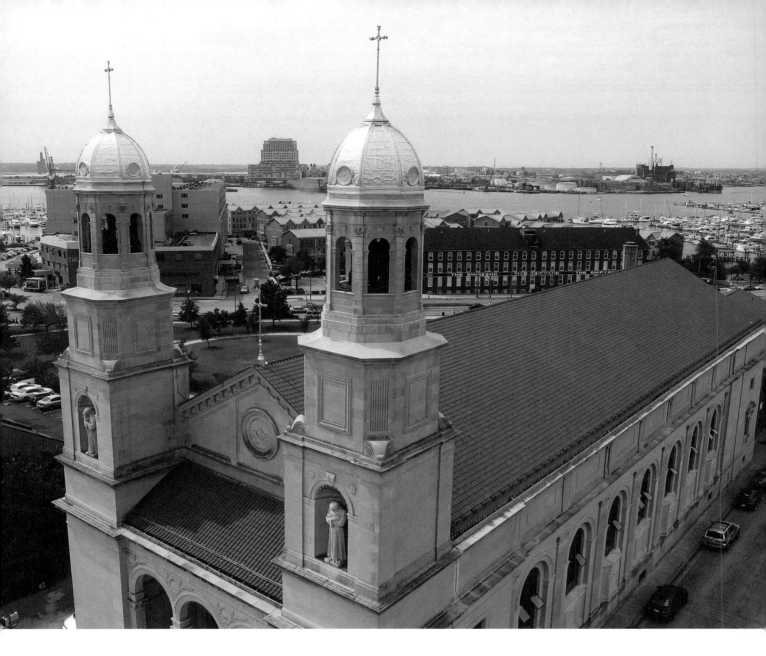

# St. Casimir

Canton, Baltimore, MD

44

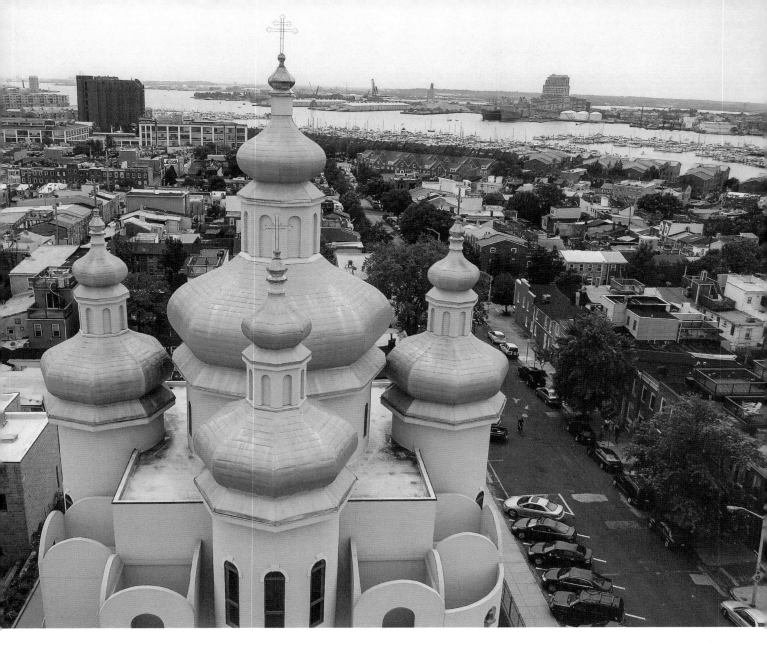

## The Archangel
Canton, Baltimore, MD
45

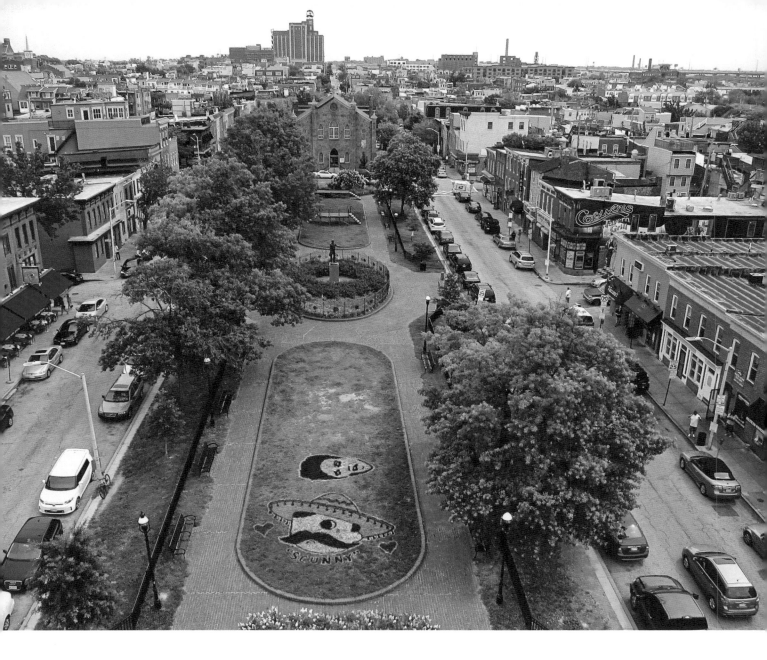

## Canton Mourns

Canton, Baltimore, MD

46

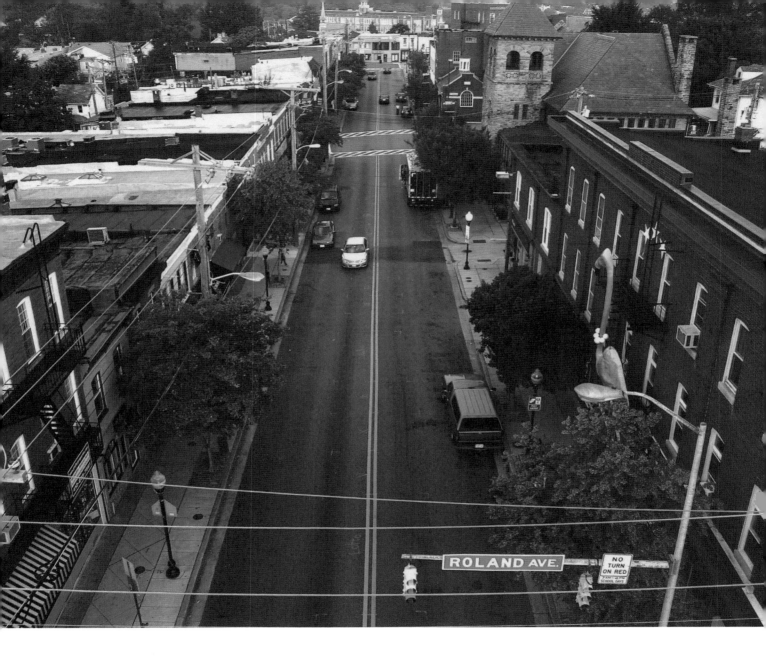

ROLAND AVE.

NO TURN ON RED

The Ave, Hon
Hampden, Baltimore, MD

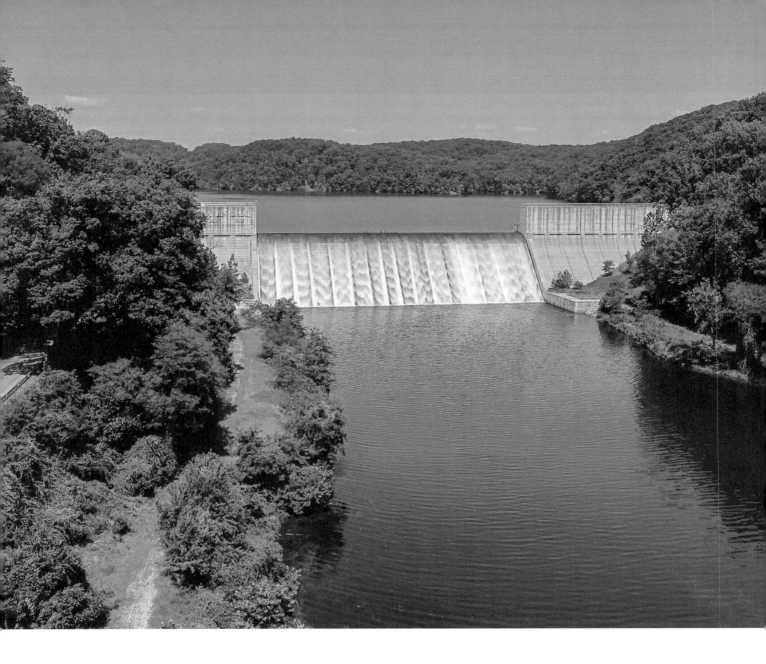

# Loch Raven Dam

Timonium, MD

48

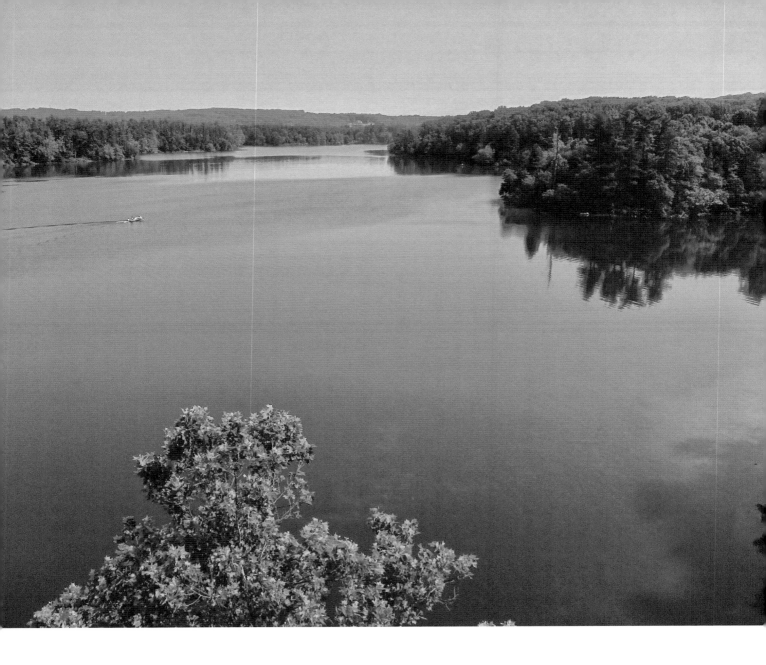

# Loch Raven Reservoir

Timonium, MD

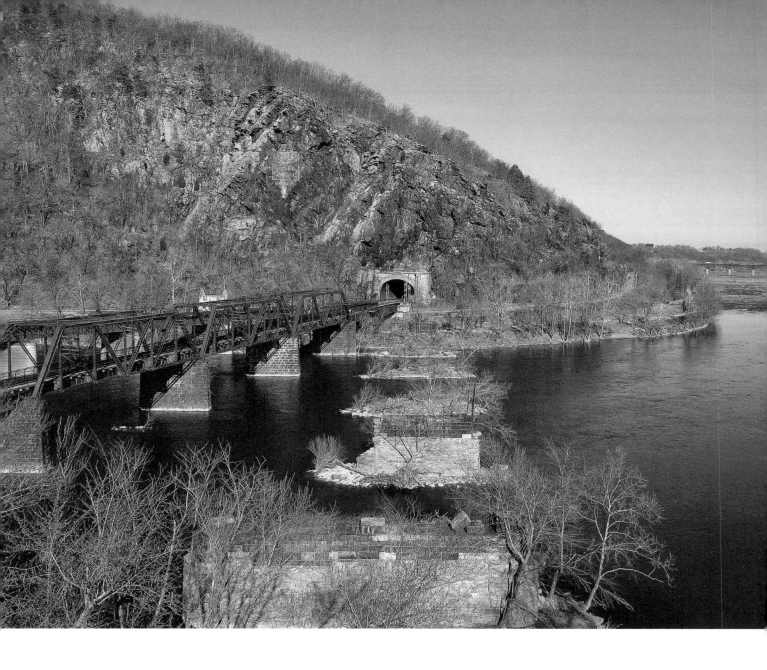

# Train Tunnel

Harpers Ferry, WV
50

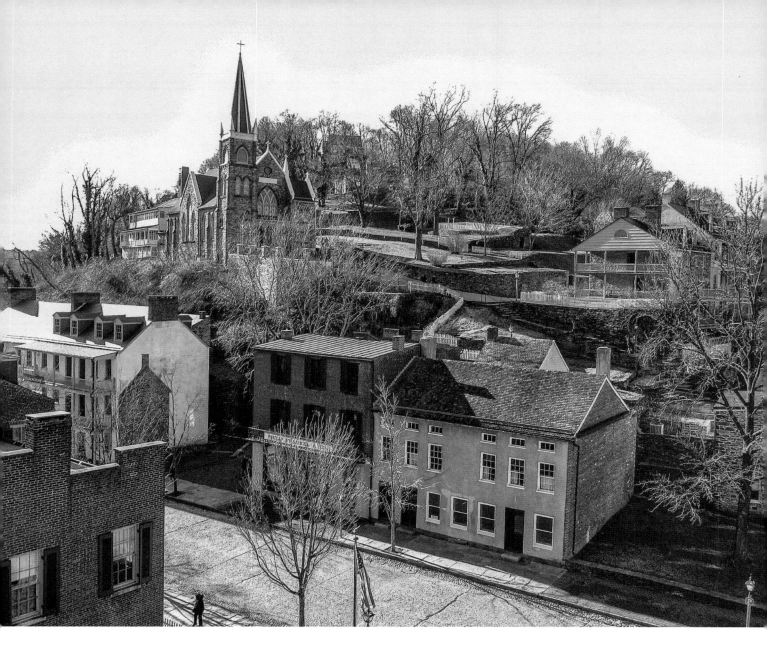

St. Peter's

Harpers Ferry, WV

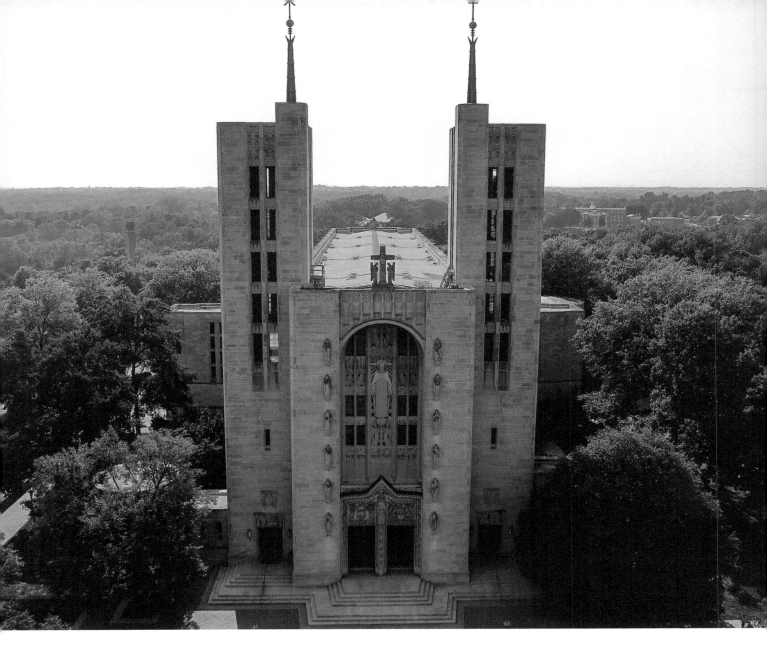

# Mary Our Queen

Baltimore, MD

52

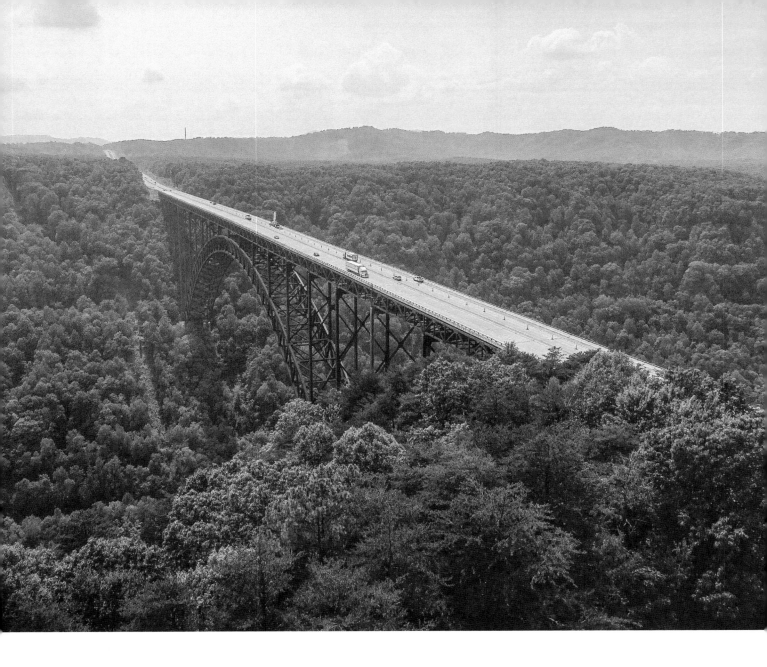

New River Gorge Bridge

Fayetteville, WV

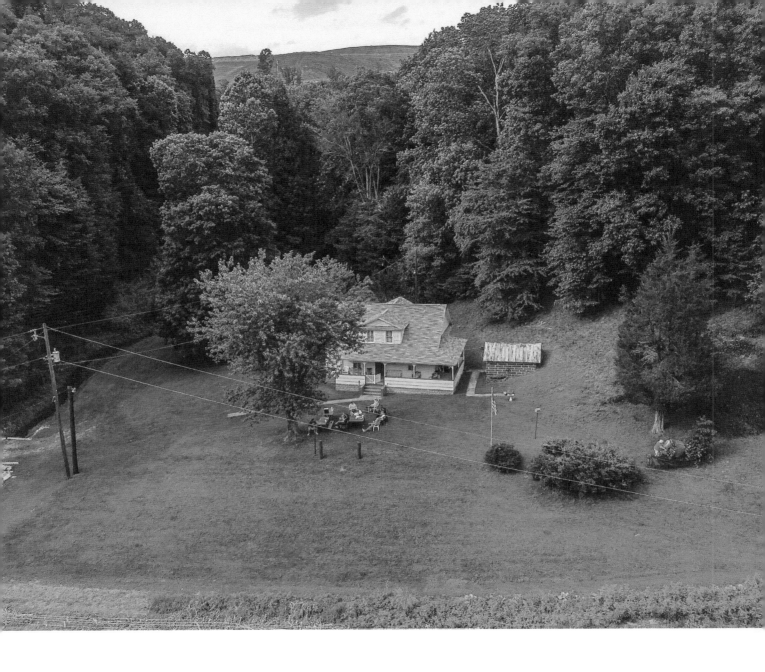

# Mountain Makeover

Mud River, WV

# Mud River

Mud River, West Virginia was once an ideal location to set roots and raise a family. That is exactly what John and Lydia Caudill planned to do when they built the farm house pictured on the opposite page back in 1920. The pair had inherited 75 acres of land and wanted to build a home that they could keep in the family for generations to come. The house sat at the base of a majestic mountain with lovely creeks that eventually feed into the Mud River. The land was rich and able to support large gardens that yielded lots of home grown food all throughout the area.

Today, things have changed. The Caudill home is the last one standing in the area as coal mining companies have bought up all of the surrounding properties. They began a damaging process called strip mining, also known as mountaintop removal. The surviving heirs of the Caudill family, whom Belinda is distantly related to, continue to fight legal battles to keep the dreams of their parents alive. In this photo, you can see the huge gap in the center of the ridge. This area was once a densely forested home to all types of wildlife. Now, that same land sits bare and empty. Since the 1970's mountaintop removal has become the predominant means of extracting coal. It has cleared 1.4 million acres of forested hills, buried 1,200 miles of streams, changed the contours of The Appalachian Mountains and added 75 billion dollars a year to public health costs.

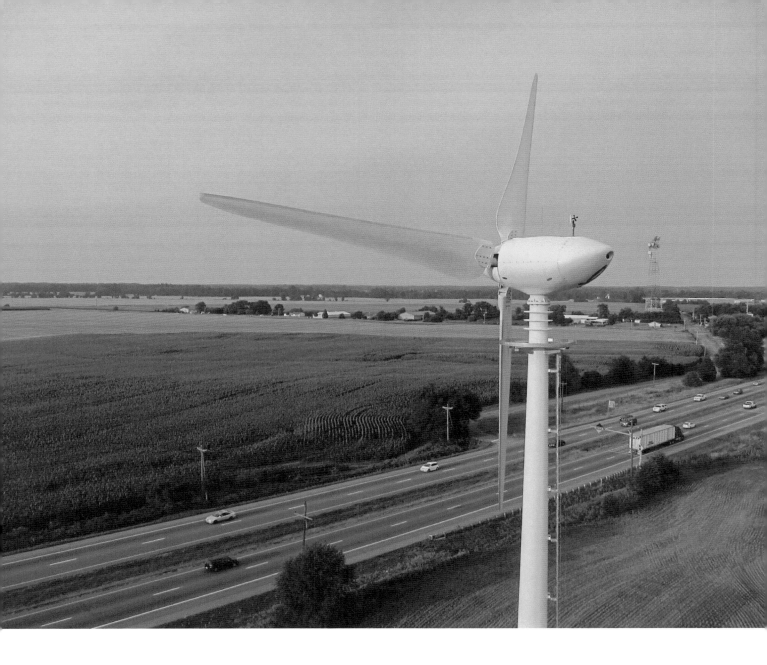

Chesapeake Turbine

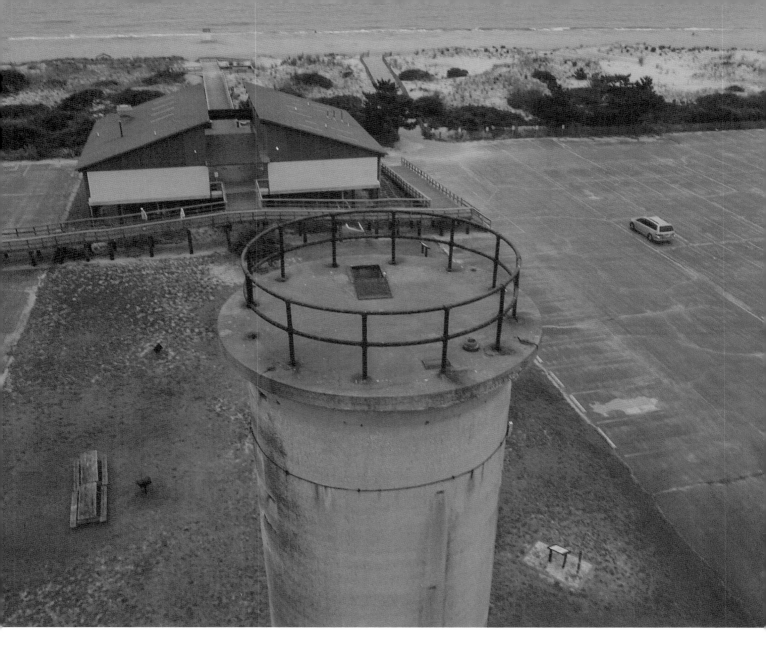

WW 2 Lookout

Rehoboth Beach, DE

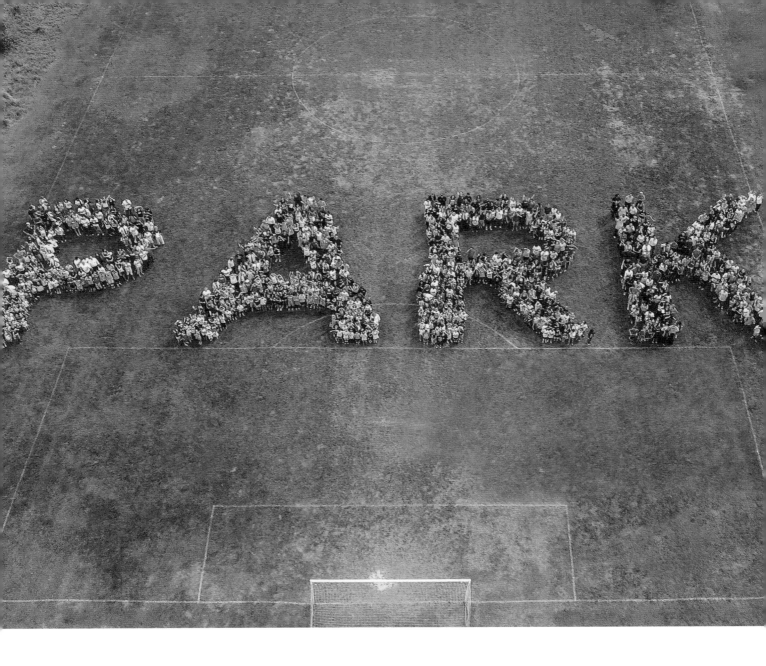

## Centennial Pride

The Park School, Baltimore, MD

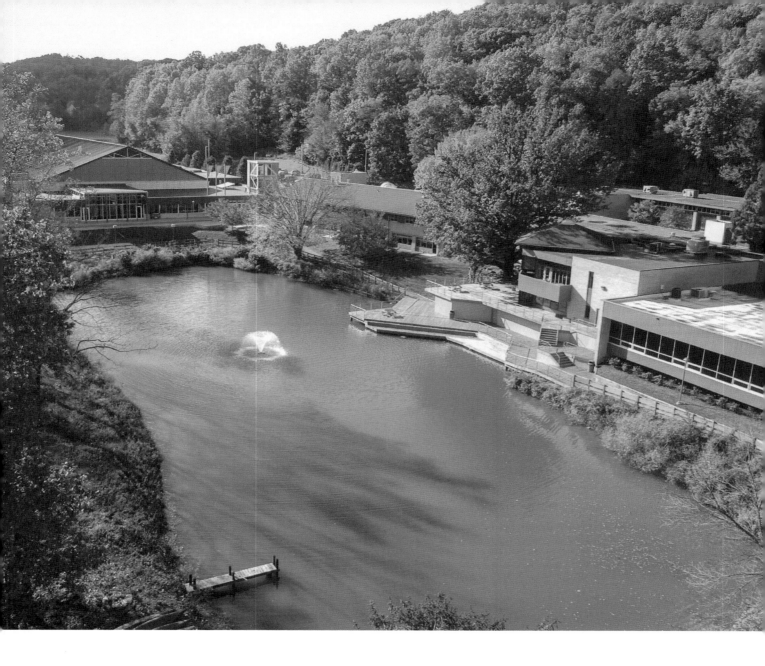

Fall Classes

The Park School, Baltimore, MD

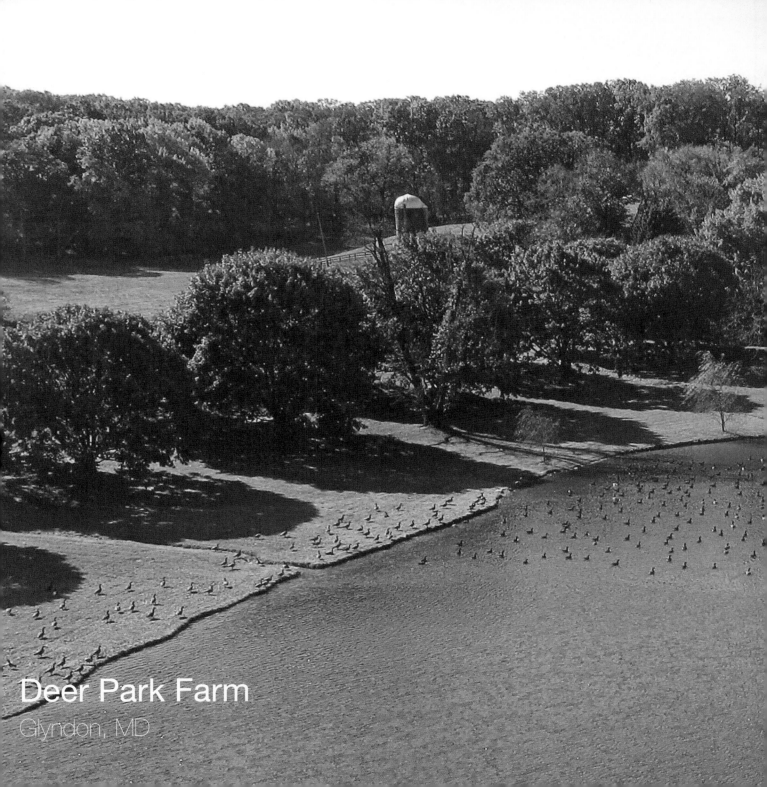

Deer Park Farm
Glyndon, MD

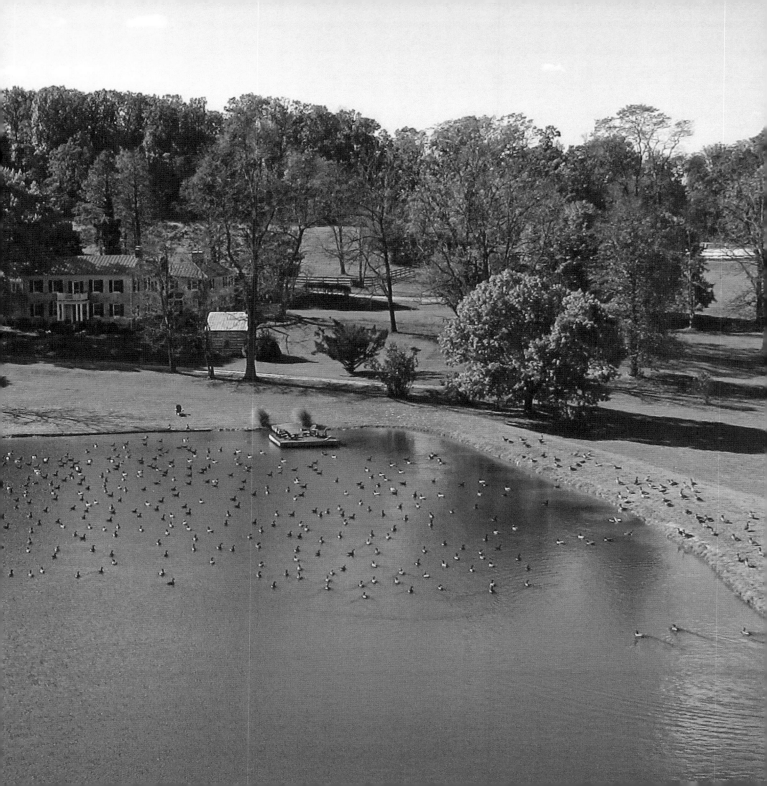

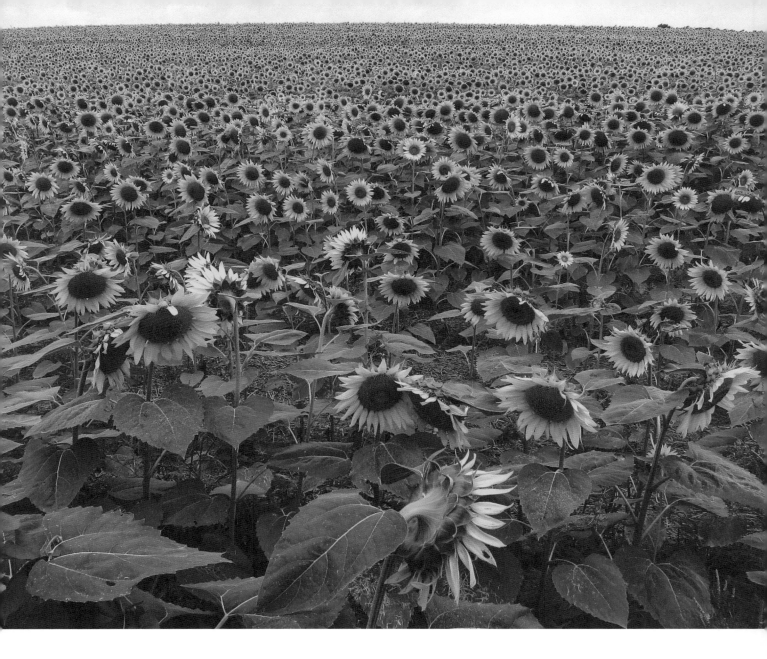

## Sunflowers 01

White Hall, MD
62

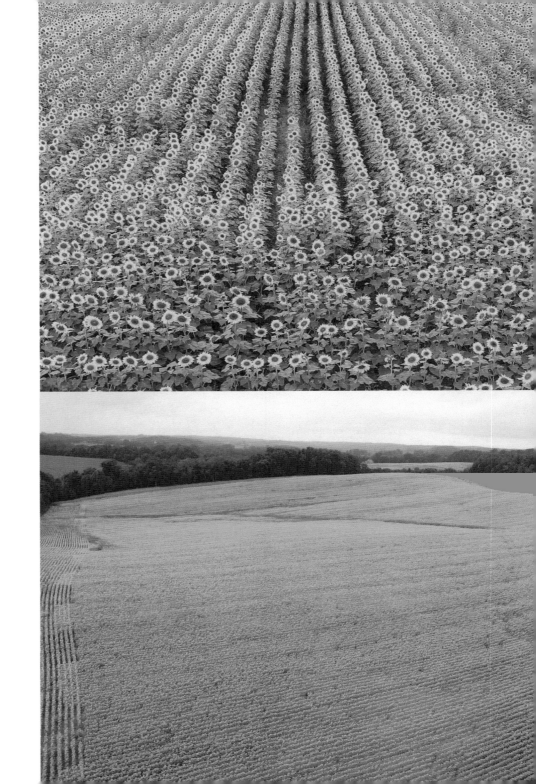

# Sunflowers 02
White Hall, MD

# Sunflowers 03
White Hall, MD

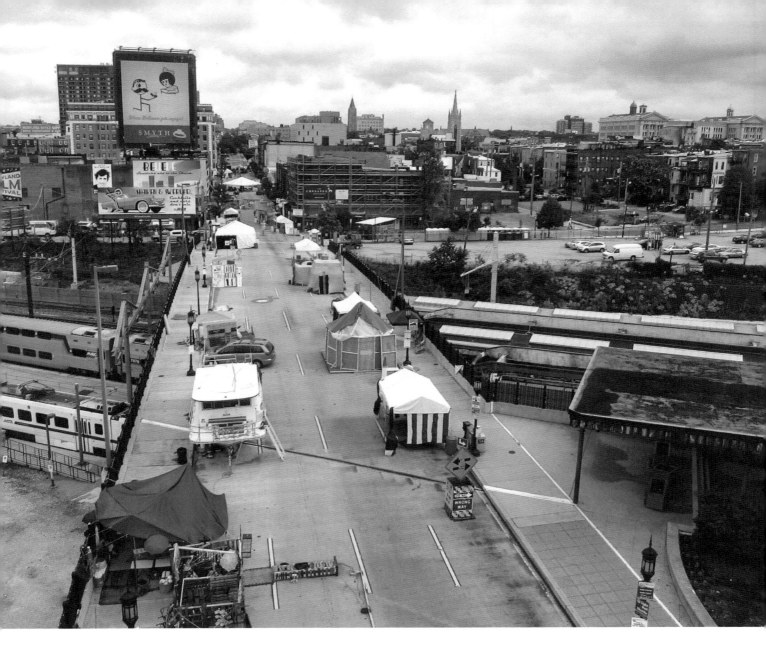

## Two Employers

Mt Vernon, Baltimore, MD

64

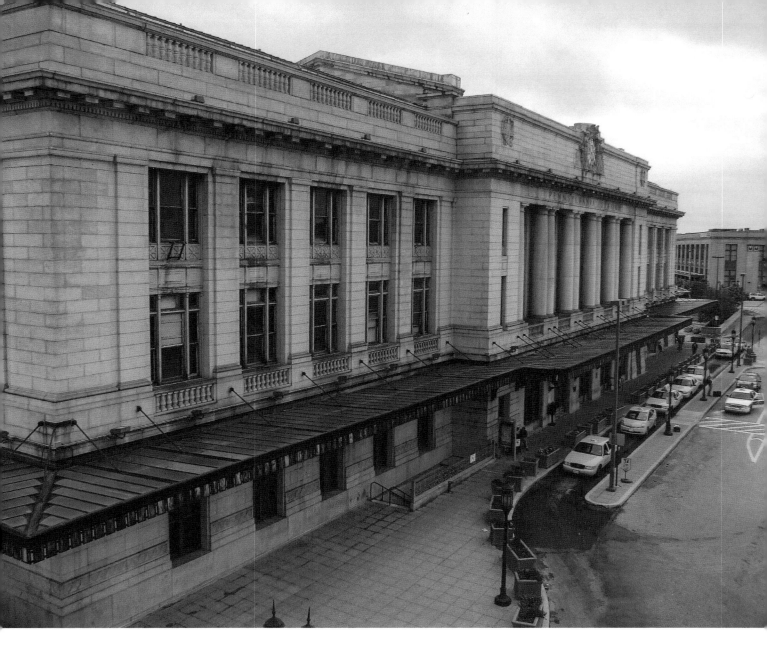

## Taxi Row

Mt Vernon, Baltimore, MD

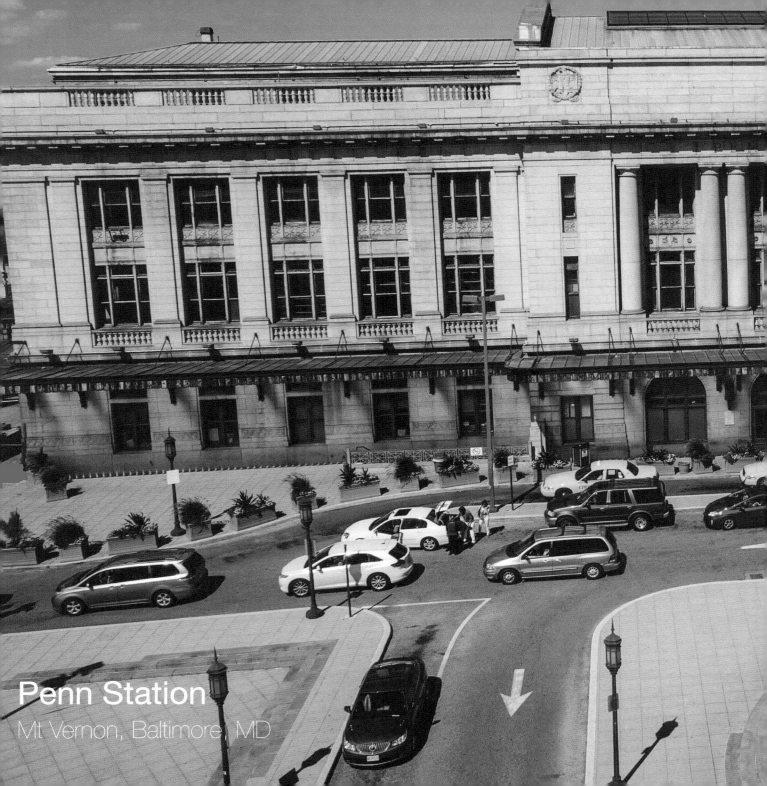

Penn Station
Mt Vernon, Baltimore, MD

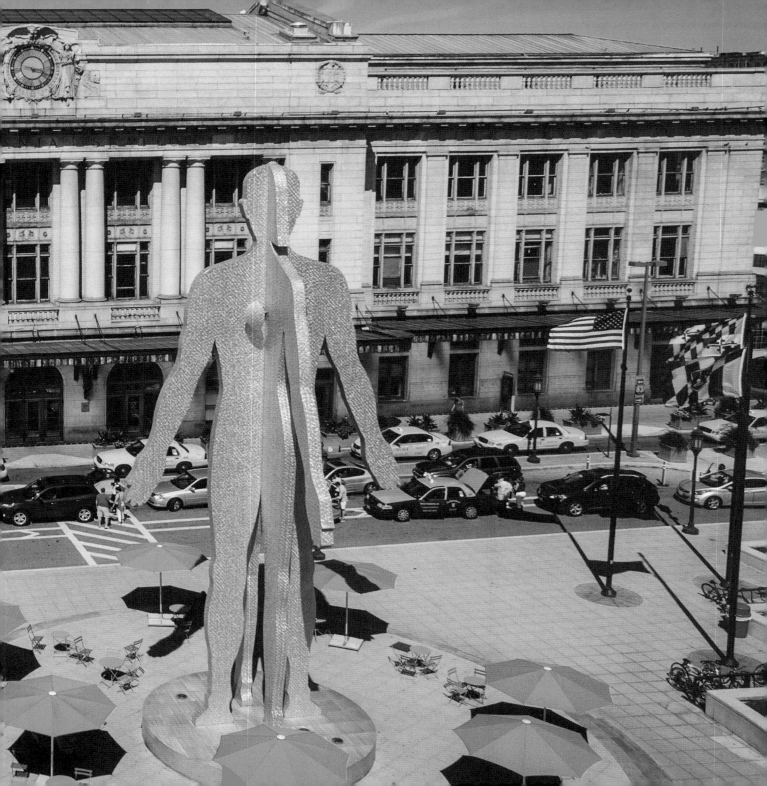

# Mt Royal Station

Bolton Hill, Baltimore, MD
68

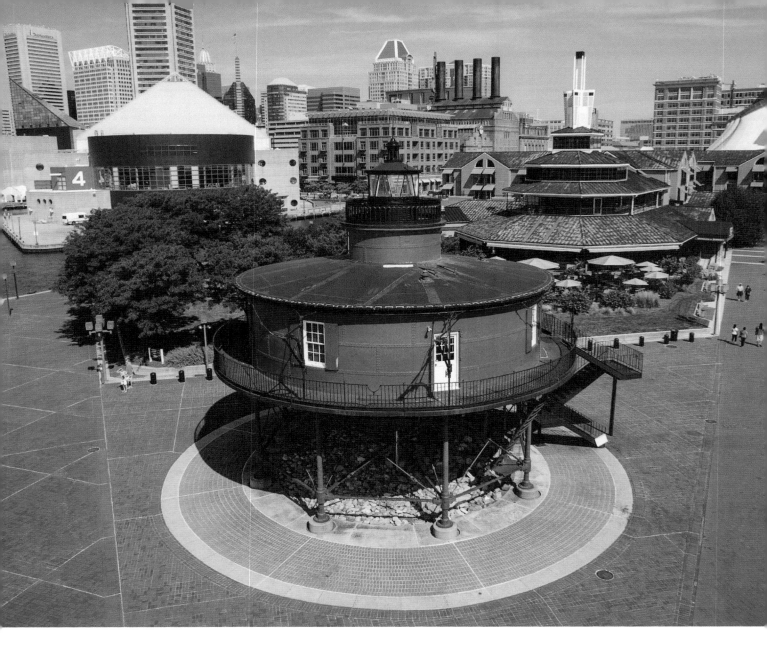

## Seven Foot Knoll

Inner Harbor, Baltimore, MD

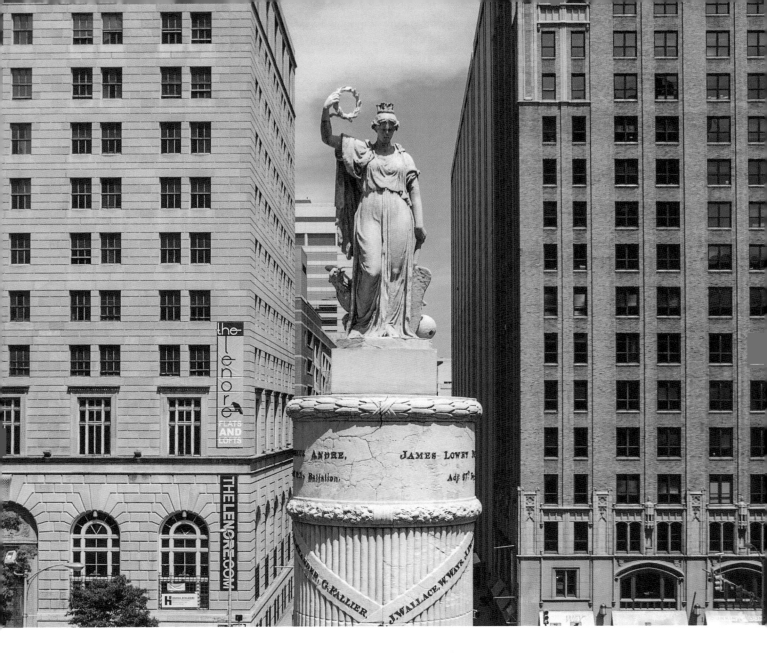

# Battle Monument

Mt Vernon, Baltimore, MD

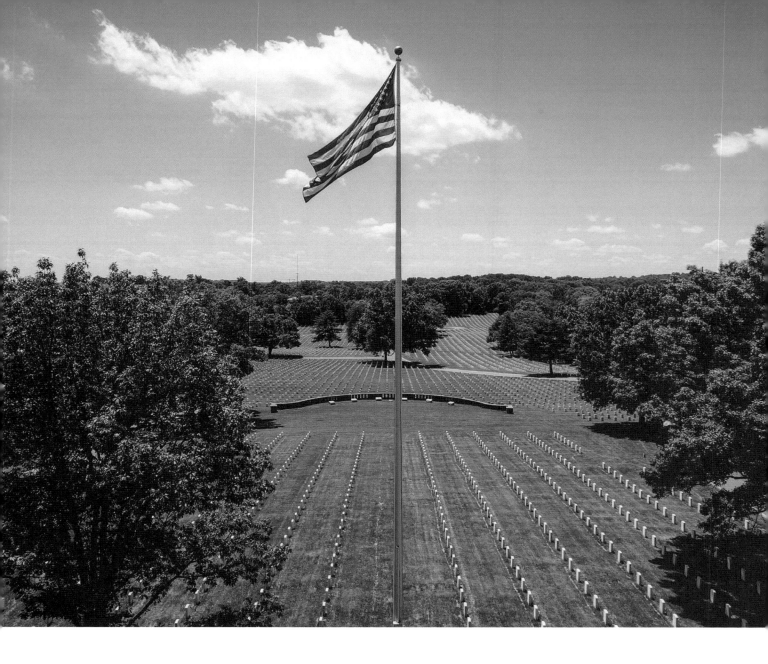

Baltimore National Cemetery

Catonsville, MD

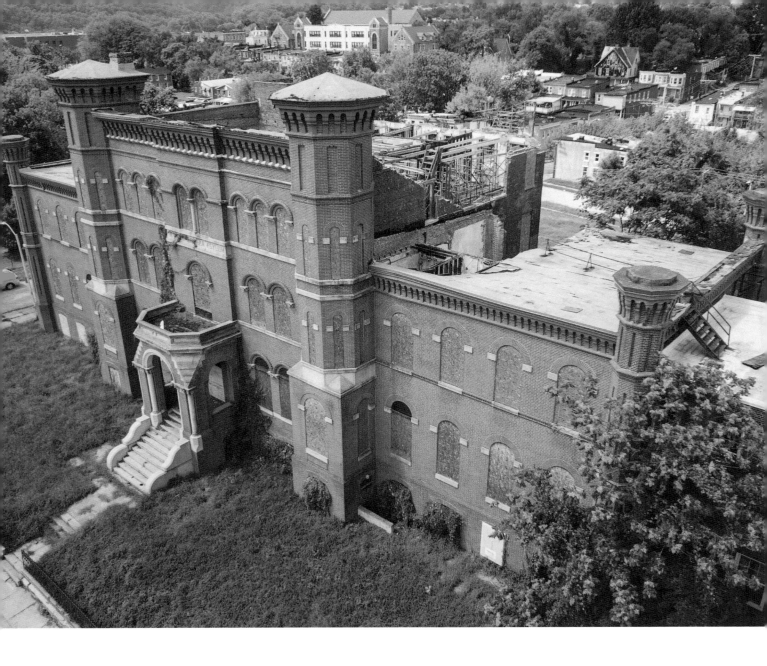

# Hebrew Orphan Aslyum

Mosher, Baltimore, MD

72

# Hebrew Orphan Asylum

Built in 1875, this amazing building has been many different things over the years, but it started life and will forever be known as the Hebrew Orphan Asylum. It was built on the site of the old Calverton Mansion (built in 1815) after a fire destroyed that structure in 1874. The Hebrew Orphan Asylum originally started in the old Calverton Mansion back in 1872 and was funded by the Baltimore Jewish community that took residence in the city. The building later served as the West Baltimore General Hospital from 1923 through 1945 before finally becoming the Lutheran Hospital of Maryland. It remained in use until 1989 when it was finally closed for good. The building is now owned by Morgan State University, and there is a community effort to restore this building to its former glory. As you can see in the photo, the roof is currently being replaced in hopes to slow down the deterioration of the Victorian Romanesque structure.

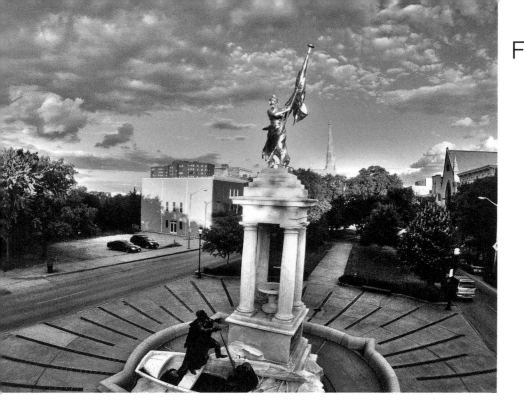

## Francis Scott Key 2010
Bolton Hill, Baltimore, MD

The evolution of Elevated Element's photography and overall skill level is best represented by these images of the Francis Scott Key Memorial Monument. It is located on Eutaw Place and Lanvale Street in the Baltimore neighborhood of Bolton Hill where Terry and Belinda first embarked on their journey. Just outside their front door, atop of the monument, stands the gilded sculpture of Columbia, the goddess of liberty. Her domain became the natural proving ground for testing the various devices built to carry each newly acquired camera. The photo from 2010 was shot with the first GoPro camera, and has that tell tale fisheye effect and lower resolution. Early on, Terry experimented with high dynamic range (HDR) filters. They looked cool, but it was soon determined that capturing better quality images would alleviate the need for such drastic edits. The final photo from 2013 was taken with a Sony NEX. It's sharper and required far less editing, but it is also from a higher perspective and is much closer to the subject. The overall increased design, photography and piloting abilities are evident, and clearly conveys just how far the pair have progressed over the last few years.

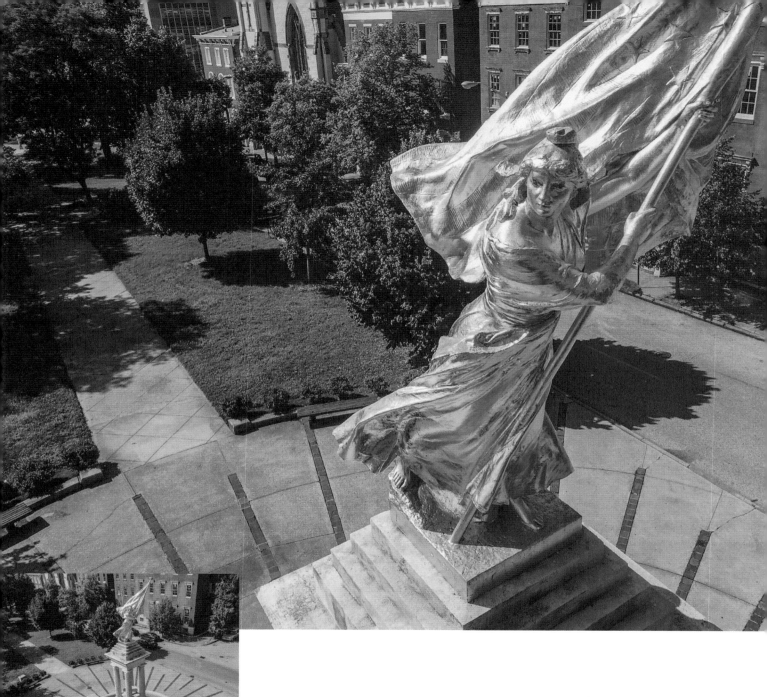

Francis Scott Key 2013

Bolton Hill, Baltimore, MD

I do not think there is any thrill that can go through the human heart like that felt by the inventor as he sees some creation of the brain unfolding to success.

-Nikola Tesla

# Summary

Baltimore is where Elevated Element began, but they are naturally looking to travel, and photograph much that the world has to offer. The journey is an important element in this artistic endeavor. There's a lot out there that needs to be seen from an elevated perspective. Terry and Belinda have taken some road trips, but are very much interested in some more remote destinations. Sacred ancient spots such as Machu Picchu, Peru and the Mayan ruins on Mexico's Yucatan Peninsula are just a couple at the top of their list. However, any sites with aesthetically pleasing design details are good candidates to photograph. They plan to create a series of Drone Art books based on various geographical regions. Belinda has always felt that it is our personal duty to learn as much as one possibly can throughout life, by meeting new people, experiencing new things and traveling to new places.

Other than fine art photography, Elevated Element is also dedicated to promoting STEM education initiatives. STEM stands for science, technology, engineering and mathematics. Any of these subjects and more may be reinforced with students, by learning how to build and fly unmanned aerial vehicles (UAVs) or drones. Terry and Belinda are passionate about teaching students that they are capable of being makers; that they can design and build whatever they put their minds too. Belinda, a former visual art educator has developed a comprehensive aerial robotics curriculum that may be customized for any learning group's needs. What could possibly be cooler than a flying robot to peak student's curiosity and optimize engagement?

Another important way that they infuse technology into the learning process is through social media. Terry, who is also a developer, has created a website called

Drone Club, which is an online forum exclusively for students and educators interested in building multicopters. By participating in the dialogue on the Drone Club site students can share design ideas, ask questions and explain to others how they solved problems encountered along the way. This can be related to crowd sourced research, which is a key component of open source software, an important direction of technology in the future. Communication skills are strengthened, but being able to explain concepts to others takes the depth of knowledge on a topic to a whole new level. There's tremendous demand for workers who possess technology skills. The U.S. Department of Education says they are launching a $265 million STEM Innovation Initiative to help ensure our students succeed in a global economy. Go to www.whitehouse.gov for more details about this plan.

Through education Elevated Element is working to change the connotations currently associated with the word drone. This technology is not only used for weaponry and surveillance anymore. In fact, many nations are well ahead of the United States in developing an entire drone centered industry. Drones alleviate the need for putting human life at risk in dangerous situations. Here are some ways that unmanned aerial vehicles, or drones may assist us, by doing in hours what would normally take years.

Precision agriculture is a technology based farm management system with the goal of optimizing returns on inputs while preserving resources. Farmers will be able to monitor plant health much more quickly from the comfort of an office or a tractor mounted tablet.

Environmentalist face many obstacles in their conservation efforts. Drones will greatly assist them in monitoring illegal poaching and excessive deforestation.

They will also more easily be able to track movement of species, and assess pollution over vast areas.

Humanitarian groups who are trying to efficiently distribute various types of aid will be able to obtain an overview of the landscape and determine open passageways. They will be able to estimate the number of refugees, their movement, and even carry supplies.

Changing weather patterns appear to be playing a role in the rise of natural disasters such as floods or wildfires.  Destruction may also be the result of man's actions. Drones are already assisting search & rescue workers. They are able to assess the size of the area and degree of destruction, plan routes, and pinpoint the location of those in immediate need of being rescued.

Drones make infrastructure Inspection much safer when trying to obtain difficult to reach perspectives.  Engineers who are responsible for skyscrapers, bridges, towers and pipelines will safely be able to check routine maintenance, and identify needed repairs.

Archaeologists face  their own set of challenges. Under increased development deadlines, they need to drastically speed up the surveying process. Drone technology can provide 3D models of the site and utilize infrared systems to determine the depth of objects. They will also help protect the artifacts from looters, by monitoring from above.

Drones are making a big splash in the area of art and culture. Elevated Element has demonstrated how they use drones to create fine art aerial photography. Drones are also widely used in film. The first aerial vehicle footage that earned an

Academy Award in the Technical Achievement category was in 1986. Imagine what filmmakers are capable of now. Drones enable closer shots at sporting events too without interfering in the action.

A more obvious function of drone technology is in generating extremely accurate maps. Using autonomous (GPS) fixed wing aircraft to stitch data/images of vast areas together can create 2D or 3D maps for a boundless number of purposes.

The positive possibilities for this new technology is only limited by human ingenuity and creativity. Each function that will be made easier through the use of UAVs will eventually have a specialized drone that will perform that task most efficiently. After more than three years of building and flying multicopters, Terry has designed a hybrid quadcopter body that he completely fabricates himself. Elevated Element has little by little acquired the equipment necessary to now have their own in-house makerspace. They plan to market their frames and parts to others who are looking to build their own multicopter with tried and true designs.

Contact Elevated Element for information on how you or your educational group can get involved with this exciting new industry. Consider yourself warned though. In the words of the great Leonardo da Vinci, "For once you have tasted flight you will walk the earth with your eyes turned skywards, for there you have been and there you will long to return."

www.elevatedelement.com
www.twitter.com/elevatedelement
www.facebook.com/elevatedelement
www.droneclub.org